Digital Photography
FOR DUMMIES®
QUICK REFERENCE

Digital Photography
FOR
DUMMIES®
QUICK REFERENCE

by David D. Busch

wiley.com

John Wiley & Sons Canada Ltd.

◆Toronto, ON◆

Digital Photography For Dummies® Quick Reference

Published by:
John Wiley & Sons Canada Ltd.
22 Worcester Road
Etobicoke, ON
M9W 1L1
www.wiley.ca (John Wiley & Sons Canada Ltd. Web site)
www.dummies.com (Dummies Press Web Site)

National Library of Canada Cataloguing in Publication

Busch, David D
 Digital photography for dummies : quick reference / by David D. Busch.

ISBN 0-470-83286-X
 1. Photography–Digital techniques. 2. Digital cameras. I. Title.

TR267.B88 2002 778.3 C2002-904390-5

Printed in Canada

1 2 3 4 5 TG 06 05 04 03 02

Distributed in Canada by John Wiley & Sons Canada Ltd.

For general information on John Wiley & Sons Canada Ltd., including all books published by Wiley Publishing, Inc., please call our warehouse, Tel: 1-800-567-4797. For reseller information, including discounts and premium sales, please call our sales department; 416-646-7992.

For press review copies, author interviews, or other publicity information, please contact our marketing department: Tel: 416-646-4584; Fax: 416-464-4448.

For authorization to photocopy items for corporate, personal, or educational use, please contact Cancopy, The Canadian Copyright Licensing Agency, One Yonge Street, Suite 1900, Toronto, ON M5E 1E5; Tel: 416-868-1620; Fax: 416-868-1621; www.cancopy.com.

About the Author

David D. Busch has been demystifying computers, digital imaging, and photography since the early 1980s with nearly 70 books and 2500 magazine articles for dozens of leading computer and photographic magazines, including *Macworld, Computer Shopper, The Rangefinder,* and *The Professional Photographer. Digital Photography For Dummies Quick Reference* is his second book in the *For Dummies* series. Before he was seduced by the dark side of technology in 1977, Busch operated his own photo studio and had his work published on the covers of magazines and in both print and television advertising. He says his chief motivation in writing books these days is to create venues for publishing photos of his wife and four children.

Dedication

For Cathy, the kids, and the country of Spain, without which this book would have a lot of blank white spaces where the illustrations were supposed to go.

Author's Acknowledgments

Thanks to David Mayhew, Tom Heine, Laura Moss, Kathy Yankton, and John Gravener for keeping on top of this project; Tonya Maddox, for keeping it moving; Paula Lowell, for keeping it readable; and Al DeBat, for keeping it accurate.

Publisher's Acknowledgments

We're proud of this book; please e-mail us your comments to canadapt@wiley.com. Some of the people who helped bring this book to market include the following:

Acquisitions and Editorial

Executive Editor:
Joan Whitman

Editor:
Melanie Rutledge

New Business Development Manager:
Christiane Coté

Production

Publishing Services Director:
Karen Bryan

Layout and Graphics:
Kim Monteforte,
Heidy Lawrance Associates

John Wiley & Sons Canada Ltd.:
Bill Zerter, Chief Operating Officer
Robert Harris, Publisher, Professional and Trade Division

Publishing and Editorial for Consumer Dummies:
Diane Graves Steele, Vice President and Publisher, Consumer Dummies
Joyce Pepple, Acquisitions Director, Consumer Dummies
Kristin A. Cocks, Product Development Director, Consumer Dummies
Michael Spring, Vice President and Publisher, Travel
Brice Gosnell, Publishing Director, Travel
Suzanne Jannetta, Editorial Director, Travel

Publishing for Technology Dummies:
Andy Cummings, Acquisitions Director

Composition Services:
Gerry Fahey, Executive Director of Production Services
Debbie Stailey, Director of Composition Services

Contents at a Glance

Table of Contents

Digital Photography

Digital photography is a wonderful, convenient blend of two technologies: photography and computers. By combining all the great things about photography (capturing memories, preserving the precious moments of our lives, and providing a vehicle for creative and artistic expression) with the immediate gratification of seeing your pictures as soon as you take them, this techno-marriage offers so many advantages. No more running to the drugstore to buy film or pick up prints anymore. No more negatives to lose, no more mountains of photos to archive, and no more prints that fade. Use this guide for a quick tour through this advancement in photography.

In this part . . .

- ✔ What You See: Parts of a Digital Camera
- ✔ The Basics: Your First Pictures
- ✔ What You Can Do

What You See: Parts of a Digital Camera

All digital cameras share certain components, such as a lens, viewfinder, and shutter release. Many additional features not found in the most basic cameras are common to a broad range of upscale models, such as a zoom lens and a slot for removable storage. The following list describes features found in most digital cameras. Your camera may not have all of them.

- **Power switch:** Press to make the camera active by turning on the sensor, making the electronic flash ready, and, often, illuminating the LCD (liquid crystal display) viewfinder. *See* "Preparing and Starting the Camera."

- **Optical Viewfinder:** Look through the viewfinder to frame your image. *See* "Composing Pictures with an Optical Viewfinder."

- **LCD screen:** View the actual image seen through your lens with this electronic display. *See* "Composing Pictures with an LCD screen."

- **LCD Status Readout panel:** View the number of exposures taken or remaining, quality level, flash status (on/off/automatic, and so on), and other information. *See* "Preparing and Starting the Camera."

✔ **Control buttons and knobs:** Adjust camera settings, such as quality level, flash mode, zoom setting, and so forth. *See* "Preparing and Starting the Camera."

✔ **Optical zoom lens:** Adjusts magnification of the image, making it larger or smaller. *See* "Composing Images."

✔ **Hot Shoe for External Flash:** You can attach more powerful flash units here. See Part IV "Lighting it Just Right."

✔ **Slot for removable media:** Electronic "film" cards, such as CompactFlash or SmartMedia, go here. *See* Part III, "Choosing and Using Storage."

✔ **Battery compartment:** Cells to power camera functions, LCD screen, electronic flash go here. *See* "Preparing and Starting the Camera."

✔ **Handgrip:** Molded into the camera body to make it easier to hold.

✔ **Neck strap attachment:** An eyelet or loop for attaching a neck strap.

✔ **Tripod socket:** Use this screw-thread socket on the underside of the camera to attach tripods, special handgrips, electronic flash attachments, and other equipment.

✔ **Infrared sensor:** Infrared-sensitive device used to calculate distance from the camera to your subject for focusing or, in some cases, adjusting flash settings. Some cameras also have an infrared emitter that you can use to transmit pictures to your computer or printer. *See* Part III.

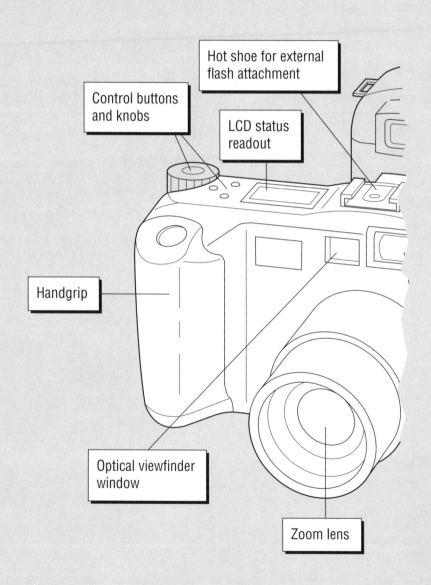

Hot shoe for external flash attachment

Control buttons and knobs

LCD status readout

Handgrip

Optical viewfinder window

Zoom lens

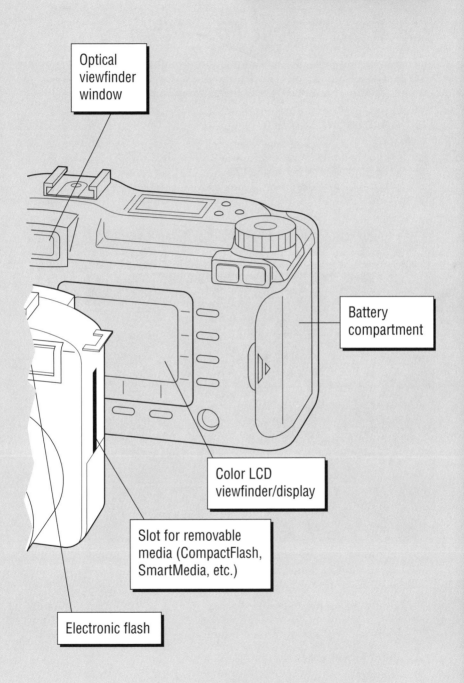

Optical viewfinder window

Battery compartment

Color LCD viewfinder/display

Slot for removable media (CompactFlash, SmartMedia, etc.)

Electronic flash

The Basics: Your First Pictures

You can be taking and enjoying your first photos within minutes of unpacking your digital camera. All you need to do is prepare your camera, compose a picture, take the photo, and transfer the image to your computer.

Setting up your camera

The first time you use your camera, or each time you replace its batteries, you may need to set up your camera, entering information such as the date, time, and preferred picture-taking modes. You need to make only the camera settings appropriate for your camera, and don't have to set them in the order shown here.

1. Use your camera's controls to enter setup mode.

 Consult your camera's provided instructions. Your camera's setup mode consists of a series of menus allocated to each particular type of setting you can make. You use several buttons on your camera to move up or down in the menus, over to different menus, and to select an item.

2. Adjust the camera to the correct date.

The date displays on your camera's LCD panel and is included with the image file when the picture is transferred to your computer, so you know exactly when it was taken.

3. Adjust the camera to the correct time.

 Some cameras may let you choose between 24-hour and 12-hour time scales.

4. Turn on or off special features available in your camera from the available menus. These features may include

 • Audio signals that sound when the camera takes a picture and/or is ready for another picture, or that represent other picture-taking events.

 • An information display of data that you may or may not want to view, such as date and time.

 • The default quality mode — the resolution setting — the camera will use unless you specify another mode during a picture-taking session. For more information on resolution, see also Part II.

 • Whether playback mode (the mode that shows you the pictures you've already taken) displays one picture at a time, or several of them (for example, two rows of two or three rows of three).

 • The language used for the informational displays of your camera — for instance, English, French, German, or Japanese.

Preparing and starting the camera

Make a quick check of your camera each time you begin a snapshooting session to ensure that it's ready to go:

1. Turn on the camera.

2. Check the LCD panel's battery icon to ensure that batteries are charged and ready for picture-taking. Replace batteries if necessary.

 Your camera has a series of icons, similar to those that follow, that show the relative amount of power remaining in your batteries, with a fully-charged battery shown at top, and a ¾ discharged battery at the bottom.

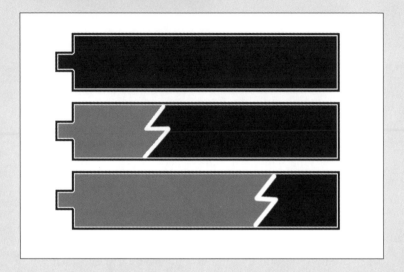

3. Examine the camera lens from a slight angle to make sure no fingerprints, smudges, or other debris are on it that can affect your picture quality.

 Use only special camera lens-cleaning fluid and lint-free lens-cleaning tissue to clean the lens. At the very least, breathe onto the glass surface to add a little moisture before cleaning. Rubbing dust around on a dry lens surface can scratch the glass or plastic. *See also* Part II for more information.

4. Check the LCD panel's display to see the number of pictures remaining.

 TIP Have extra digital "film" memory modules available. Or you may want to erase unwanted photos before you begin your new snap-shooting session. (Deleting photos is done differently with different kinds of digital cameras. For information on how to delete photos, see your camera's instruction book.)

5. Check the LCD panel's display to determine the quality level and adjust to the setting you want, if necessary. Your camera will denote quality level using a series of stars or another kind of icon.

 Higher quality levels provide the sharpest results, but the fewest number of pictures with a given amount of storage.

6. If your camera offers both black-and-white and color mode, double-check the LCD panel's display to view the current mode, and adjust if necessary. The icon or message used to represent color or black-and-white mode varies by type of camera.

 You get more pictures in the available storage with black-and-white mode.

Composing images with an optical viewfinder

When your camera is prepped, view your subject and compose a picture. The optical viewfinder is the fastest way to frame a picture. Most digital cameras have both an optical viewfinder and an LCD viewfinder. To frame a picture, follow these steps:

1. Place the viewfinder to your eye to view the scene.

 With a standard optical viewfinder, you see the subject through a window, usually placed to the left side of the camera. With a high end SLR (single-lens reflex) camera, you view the subject through the actual lens that takes the picture.

2. Zoom in or out using your camera's zoom controls to adjust the size of the image.

3. Change the lens to its Close-Up setting if you want to take a close-up picture.

4. Frame your picture within the viewfinder to include only the subject matter you want.

5. If you're using a non-SLR optical viewfinder, adjust the image for parallax.

Optical viewfinders usually have a pair of lines at the top and sometimes to the left side of the view screen. Keep your subject matter inside these lines to ensure that you won't "cut off" the top of someone's head, or otherwise trim your image without intending to. For more information on parallax, ***see also*** Part VI.

 Parallax is the phenomenon that accounts for the difference between what an optical viewfinder sees and what your camera lens, located an inch or two away, actually sees. Parallax is most evident when shooting pictures up close.

Composing images with an LCD screen

Although you use the LCD screen most often to review pictures after you take them, you can also use it to compose a photo. This option, which shows the exact image the camera's sensor sees, works best for close-up pictures, because a traditional optical viewfinder can cause you to cut off part of the image. To compose an image with the LCD screen:

1. Turn on your camera's LCD screen if it's not already on.

2. If bright light is shining on the LCD screen, use your body to shield the display so that you can view the image clearly.

3. Frame the picture using the image you see on the LCD screen.

4. Change to your lens's Close-Up setting if you want to take a close-up picture.

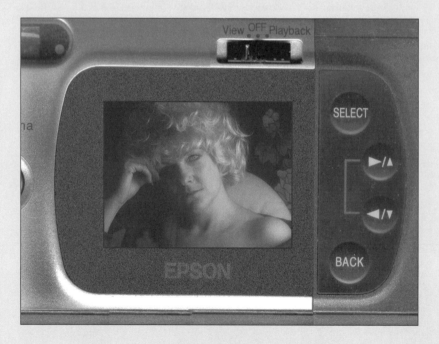

Setting flash mode

You may need to adjust the flash setting of your camera, depending on whether you take the picture indoors, outdoors, or under mixed lighting conditions. *See* Part IV, "Lighting It Just Right," for more information.

1. Choose a flash setting.

- Use Auto Flash to let your camera trigger the flash automatically when there isn't enough light.

- Use Manual Flash/Fill Flash when you want the flash to always go off.

- No Flash turns the flash off completely, even under low illumination.

- External flash lets you use an external electronic flash.

- Red-eye reduction mode reduces the orange or red pupil effect.

2. Turn on the flash, if necessary.

3. Watch for an LED alert, usually located near the viewfinder, that glows red when the flash is not ready to take a picture, and turns green when the flash is ready.

Locking in exposure and focus to take a picture

Just before you take a photo, you want to lock in the exposure and focus settings. For more information on exposure, *see also* Part IV.

1. Examine your subject.

If you see any very bright or very dark areas in your picture, step in close and reframe your subject temporarily so that only the area you want exposed and focused correctly is shown in the viewfinder.

2. Press the shutter button down halfway and hold it there.

This action causes the camera to lock in the exposure and focus based on the subject matter in the viewfinder.

3. With the shutter button still held down, reframe your picture to include only the subject matter you want.

TIP ⦿ If you moved in close to zero in on part of the image, you may have to take a step or two back to reframe the entire composition.

4. Press down the shutter button the rest of the way to take the picture.

Remember: Press the button gently rather than punching it to reduce the possibility of blurry images caused by camera shake.

Reviewing photos

After you take your pictures, you can review them using your camera's LCD screen:

1. If required, change the LCD screen from Preview mode to Review or Playback mode.

 Many cameras have a switch for changing the LCD screen from a "live" view of what's shown through the viewfinder in real-time, to a review mode that displays the pictures that are in memory.

2. Review your photos.

 • If your camera is set in single-picture display mode, review each photo by pressing the forward or backward buttons (usually located next to the LCD screen on the back of the camera).

 • If your camera is set to multiple-picture display mode, review the array of photos. See the following figure for a look at multiple pictures shown at one time.

3. While reviewing pictures, delete any that you don't want to keep, using your camera's provision for removing pictures from memory or your removable storage. For information on how to delete images, see your camera's instruction book.

 Removing pictures during a shooting session will provide more room for photos. If you have plenty of digital "film" you can simply transfer the photos to your computer and remove them at that time.

4. Switch from Review/Playback mode to Preview mode, or simply turn off the LCD screen to return to picture-taking mode.

Transferring photos

After you finish taking pictures, you'll want to transfer them to your computer for archiving, viewing, editing, or printing. Digital cameras often provide a choice of image transfer methods. These methods include using a serial or USB cable that connects directly to your computer, or a card reader that can copy photos from your CompactFlash, SmartMedia, or other removable storage.

 For information on storage options, see Part III of this *Quick Reference* or *Digital Photography For Dummies.* You can find more detailed instructions for transferring pictures, including additional transfer options, in Part III.

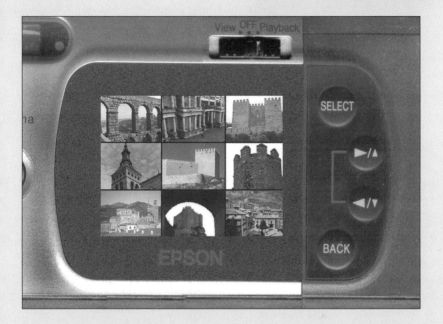

To transfer your images by cable:

1. Locate the serial cable or USB cable provided with your digital camera.

2. Plug the cable into your camera's port, which may be located under a hinged or sliding door.

3. Plug the other end into your computer's serial or USB port.

 When your computer's software "connects" with the camera, you'll be offered a choice of actions to take.

You can choose from copying all the pictures from your camera and erasing them on the camera; copying them and leaving them in place in the camera; or simply viewing the pictures in the camera without copying them, as shown next.

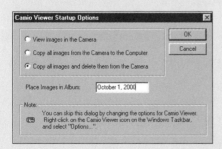

To transfer pictures via removable media:

1. Remove the media from your camera.

2. Insert the media in your card reader.

The software in your computer should "connect" with the card reader automatically and provide options for downloading or viewing the pictures.

What You Can Do

Digital cameras can provide images for many different kinds of simple projects. For example, you can create images for Web pages, shoot a portrait, or capture images for a newsletter.

Creating a Web page

Digital cameras are the perfect tool for Web page graphics, because the resolution requirements aren't demanding. For more information on getting images ready for the Web, *see also* Part VIII. Get started by following these steps:

1. Determine what software you'll use to lay out your Web page.

2. Plan the text for your Web page and leave room for photos.

3. Choose what photos you'll need.

4. Evaluate your page to make sure that each page of your Web site doesn't contain too many photos (to keep your visitors' download times fast).

5. Design your Web page using the photos you've selected.

 For information on planning and creating Web pages, see *Creating Web Pages For Dummies*.

Work on your project by following these steps:

1. Take photos at 640 x 480-pixel resolution (more than enough for Web applications).

2. Use flat lighting to provide low contrast images that are easy on the eyes. *See also* Part IV.

3. Transfer the photos to your computer. *See also* Part III.

Add the finishing touches by following these steps:

1. Use image-editing software to crop and resize the images for your Web page. *See also* Part VII.

2. Correct the color if necessary. *See also* Part VII.

3. Add the pictures to your Web page, as shown next.

See *Creating Web Pages For Dummies*.

David Jr. plays in his group Rattle Brat

- Michael Christopher, age 29, is applying his cum laude degree from Kent State University to a career in retail petroleum systems management. His significant other is a petite young lass who came equipped with a fully-functional daughter named Elizabeth, who was three years old in June, 1999. She is the apple of her doting pseudo-grandparents' eyes.

Shooting a portrait

Getting good-looking portraits is easy. Digital cameras take care of focusing, exposure, and other tasks for you. Get started by following these steps:

1. Find a location with flattering natural light. *See also* Part IV.

2. Evaluate the background, or provide your own using drapes, seamless paper, or other materials.

3. Place a comfortable stool or chair for your subject to sit on.

Continue to work on your project by following these steps:

1. Take a variety of pictures using different poses.

2. Vary the distance between you and your subject.

3. For the most flattering portraits, use the telephoto setting of your zoom lens, if possible. *See also* Part II.

4. Add extra lights for enhanced effects. *See also* Part IV.

5. Use the highest resolution available for your camera.

6. Transfer the photos to your computer. *See also* Part III.

Add the finishing touches to your photos by following these steps:

1. Use image-editing software to remove defects from the image. *See also* Part VII.

2. Correct the color and crop your portrait.

3. Print out a copy of the portrait for display.

Capturing images for a newsletter

You can capture pictures for a newsletter right up until the time you go to press thanks to the fast turnaround possible with digital cameras. Get started by following these steps:

1. Take photographs for publication using your camera's maximum resolution.

 Take a variety of pictures using different poses. Use Black and White mode if the publication is not printed in color.

2. Transfer the photos to your computer.

Work on your project by following these steps:

1. Use your image editing software to retouch the images. *See also* Part VII.

2. Size the images for your desktop publishing program.

3. Save the images in a format suitable for publication, such as PCX or TIF. *See also* Part VII.

Add the finishing touches by following these steps:

1. Import your photos into your desktop publishing program.

2. Place the photos in frames on your page.

3. Do final sizing.

4. Print your newsletter.

Blues News Reviews

King of the Blues Releases 75th Album

MEMPHIS: Riley B. King released his 75th album this week, entitled, "75 Down." The album hit big on the Blues charts at #2 with sales of more than 2 million in its first week.

The album is a followup to King's Grammy-award winning album, "I've Got The Blues Real Bad," which swept the rhythm and blues category last month.

King's new recording label, OKAY, reports that sales of the artist's back catalog have increased dramatically since his grammy award.

The album is avialable nationwide in CD and cassette formats.

Riley B. King sings the blues at the Golden Bear.

Deciding on a Digital Camera

A question like, "What's the best digital camera to buy?" is a lot like asking yourself "What boat should I get?" First, you need to decide whether you actually *need* a boat (or digital camera) and then narrow down the features you must have based on what you want to do with it.

Digital cameras are available in models ranging from under-$100 kiddie-cams to pro-quality precision machines costing $5,000–$30,000 — or more. They may have image quality — resolution — from 640 x 480 pixels to multi-megapixel (one million total pixels or more). Cameras may offer zoom lenses, self-timers, and other helpful features. Ask yourself the following simple questions to see what kind of camera you should consider.

In this part . . .

Assessing Digital Cameras

While the cost of digital cameras is dropping, an entry-level $75 conventional camera can still produce better images than your average $500 digital model. Ask yourself these questions before going further:

✔ **Do I need my pictures quickly?**

Digital cameras beat even the best one-hour photo lab for quick turnaround. If you need pictures fast for your Web site or newsletter (or you're just impatient), digital cameras provide instant gratification.

✔ **Do I take a great many pictures?**

Because you can use digital camera "film" hundreds of times, you can save big bucks on film and processing if you take many pictures.

✔ **Do I want to try many different angles and choose only a few?**

You pay for every print you get from conventional film, even if you end up using only a couple pictures per roll. You can delete and forget unwanted digital pictures.

✔ **Do I need very high image quality at a low price?**

Conventional cameras still produce the best image quality per buck. Unless you're willing to spend $500 or more, film remains your best choice if you want the ultimate in quality.

✔ **Will I make many prints?**

Conventional prints can cost a few pennies. Those you make on your own printer may cost you 50 cents to $1 or more each. If you make a lot of prints, particularly when they will be made from only a few negatives, traditional film can be more economical.

✔ **Do I want to manipulate the images myself?**

Photo labs can customize your prints with special cropping and exposure, but only to a certain extent. Digital photography gives you complete freedom to manipulate your images, as you can see in the following figure.

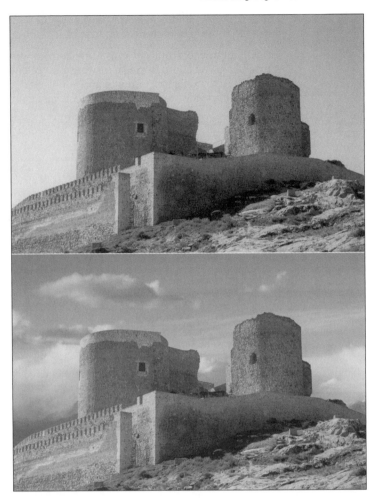

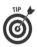

Photo labs can copy your film images to a Photo CD, floppy disk, or distribute them over the Internet using a service like AOL's You've Got Pictures. So, you may be able to manipulate traditional camera photos in your computer without investing in a scanner.

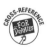

For more information on scanners, see *The Official Hewlett-Packard Scanner Handbook*.

✔ **Do I like to upgrade my cameras frequently, or would I prefer to use the same camera for a long time?**

New and improved digital cameras are rolled out every month or two. If you can afford buying a new camera (or can hand down your old model to another appreciative user), digital models will provide you with an ever-changing menu of options.

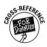

For more information comparing digital and conventional cameras, see *Digital Photography For Dummies.*

Choosing a Digital Camera Category

First, choose the category — point-and-shoot, intermediate, or advanced — you'll be considering when selecting your camera. You can narrow your search for the ideal model considerably by deciding which general type of digital camera will best suit your needs. Ask yourself these questions:

✔ **Will a point-and-shoot model do the job?**

The lowest-priced digital cameras are literally *point-and-shoot models,* with which you frame your subject in the viewfinder, and snap off a shot by pressing the shutter button. They have few options to confuse you, and not many features to give you much flexibility. If you just want to grab quick snapshots and don't need things like high resolution, a zoom lens, low-light capabilities, and scads of storage for large numbers of pictures, a point-and-shoot model may be what you're looking for.

✔ **Is the camera likely to be lost, stolen, or damaged?**

Purchasing an expensive digital camera for a child or for use in rigorous conditions rarely makes sense. If you really must have a digital camera instead of a single-use conventional picture-taker, seriously consider the lowest cost point-and-shoot cameras.

✔ **Do I need an intermediate camera?**

The next step up is a camera with features that are more convenient to use and that provide features that let you take pictures that are difficult with basic snap-shooter models. You'll also find that intermediate cameras often produce much better resolutions.

✔ **Is size important?**

If you want to slip a camera in your pocket and keep it always available, a point-and-shoot model may work best for you. However, fairly compact intermediate models also exist. Cameras that use small storage devices (such as SmartMedia), digital zoom lenses instead of optical zoom, and a small LCD screen can be quite portable. *See* Part III for more information.

✔ **Am I looking to photography as a creative outlet?**

If you want the most control over your results, intermediate to advanced cameras provide the best combination of automation and manual options for focusing, exposure, framing, and other elements of an image.

✔ **Can a digital camera complement my conventional film camera?**

If you're already an active photo hobbyist, you may want a digital camera that closely matches and complements the features of your existing equipment. That probably means through-the-lens viewing (like an SLR, or single-lens reflex camera), automatic and manual focus, zoom capabilities, multiple shot options (simulating a traditional camera's motor drive winder), and other deluxe features found only in top-of-the-line models.

You'll find more information about viewfinders later in this part.

✔ **Do I have lenses and other accessories I'd like to use with a digital camera?**

If you're willing to spend a significant sum (at least $5,000), you can purchase a digital camera built around a conventional camera body made by Nikon or Canon. These digital cameras can use the lenses, filters, flash units, and other accessories designed for their siblings. (*See* Part II.) In most cases, only professional photographers will want to make the expenditure, but serious amateurs can sometimes justify the investment.

Choosing a Lens

The lens is the "eye" of your camera, capturing the light used by your sensor to create the picture. Your choice of lens can affect the quality and convenience of your photographic experience. Some of the things you should consider include the following:

✔ **Do I need to take pictures in dim light?**

While the sensitivity of a digital camera's sensor partly determines the light levels required to take a picture, the amount of light the lens admits to the sensor — its *speed* can also be important. Lens speed is measured in f-stops: the smaller the number applied to the lens opening, the more light that can be supplied to the sensor. A f/4 or f/2.8 lens is "slow" while a f/2 or f/1.4 lens is "fast."

Lens speed relationships seem contrary because they are actually the bottom half (denominator) of a fraction. Converted to such, you can see why f/4 is larger than f/8 (as ¼ is larger than ⅛). Moreover, each f-stop increment provides twice as much light as the last: f/8 admits twice as much light as f/11; f/5.6 twice as much as f/8; f/4 twice as much as f/5.6, and so forth.

✔ **Do I want to adjust my lens settings manually?**

Virtually all digital camera lenses adjust themselves for the proper exposure automatically (except for the least expensive models with fixed-exposure lenses that you can't adjust at all). Serious photo hobbyists and professionals may also want the option found in higher-end cameras of setting the lens manually to provide special effects or more precise exposure.

✔ **Can I move around freely as I take photos — closer or farther away to change image size — or do I want to capture several views from one position, as with a zoom lens?**

A zoom lens is a convenience for enlarging or reducing an image without the need to get closer or farther away. It's an especially useful tool for sports and scenic photography or other situations where your movement is restricted.

✔ **Do I need a long zoom range?**

Cameras offer small enlargement ratios (say, 2 to 1 or 3 to 1) as well as longer zoom ranges (4 to 1 and up). If you need a long zoom range, look for cameras that provide the ratio you need.

✔ **Is sharpness an important factor while I use my lens to zoom in and out?**

Optical zoom lenses move glass or plastic elements internally to provide the best zoom quality. If your needs are less rigorous, a digital zoom lens, which provides enlargement and reduction by manipulating pixels, may be sufficient. Cameras with higher resolutions produce better results with digital zoom, because they have more information to work with.

Focal length is used to measure whether a lens provides a wide-angle, normal, or telephoto (enlarged) view with a particular size sensor or film. So, a 6.5mm focal length lens or zoom setting provides a wide angle picture with a .5-inch sensor that's roughly the equivalent of a 35mm lens on a conventional camera using film that measures 1 x 1.5 inches. Camera vendors often supply focal length equivalents for photo buffs, but all you usually need to know is whether the camera offers wide, normal, and telephoto views, and the zoom ratio between smallest and largest images.

✔ **Do I plan to shoot many close-up pictures?**

If you'll be doing a lot of tabletop or close-up photography, make sure the cameras you're considering have a close-up (or macro) setting. In addition, an easily-viewed LCD display or through-the-lens optical viewing (with a single-lens reflex, or SLR model) can make tight shots like the one shown in the following figure easier to produce.

✔ **Is automatic focus important?**

Lower cost cameras with fixed-focus lenses may not have focusing abilities at all. They provide sufficiently sharp focus at normal shooting distances (a few feet and farther) and, possibly, at a particular close-up distance (typically 18 to 24 inches). More expensive cameras have automatic focus that adjusts for the best setting at any distance.

✓ **What focus ranges should I look for?**

Intermediate and advanced cameras may have autofocusing that adjusts automatically from 20 inches to infinity in normal mode, and from 8 inches to 20 inches in close-up or macro mode.

✓ **Do you want a manual focusing option?**

Manual focusing can let you zero in on a portion of your image by making everything else seem blurry. Single-lens reflex (SLR) models often allow you to choose the focus setting yourself visually. Others may have fixed-focus settings at typical distances, such as three feet, eight feet, and infinity.

✓ **Does the lens take attachments?**

Serious amateurs and professionals often need to attach accessories to the front of the lens, such as filters, special-effects devices, close-up lenses, or lens hoods. If you need these options, look for a digital camera with a lens equipped to accept them. The ability to use add-ons in standard screw-thread sizes is a plus.

Choosing Resolution

Image resolution — the number of pixels your camera can capture — is a chief determiner of how sharp your final images will be. Choosing the resolution you require is an important first step in narrowing down your choice to a particular camera. Ask yourself these questions early in the process:

✓ **Will I make prints or just use my digital images for display on my computer or Web page?**

Digital images used with Web pages or in presentations rarely need more than 640 x 480-pixel resolution. If you don't make many prints, you may be happy with an inexpensive model that doesn't boast megapixel resolution.

✓ **Will I crop my photos?**

If you often need to trim out unwanted portions of your pictures, you probably need a higher-resolution camera (1024 x 768 pixels or more) to provide you with image information to spare, as shown in the following figure.

✔ **Do I need to make large prints?**

Most megapixel cameras produce images suitable for 4 x 6-inch prints. If you make many 5 x 7 to 8 x 10-inch prints (or larger), look at cameras with resolutions in the 1600 x 1200 pixel (or more) range.

✔ **Is image sharpness my most important concern?**

For the ultimate in sharpness, merely looking at the resolution of a camera isn't enough. Consider these factors, as well:

- **Quality of the lens:** Test several models to compare. *See* Part II for more information on this topic.

- **True resolution versus interpolated resolution:** Some cameras use interpolation to simulate a resolution beyond what their sensors can actually capture. Interpolation uses mathematical formulas to simulate the extra resolution. While this technique can work well, interpolated resolution is rarely as good as the real thing.

- **Storage format:** Digital cameras usually store photos in a compressed format known as JPEG (Joint Photographic Experts Group). JPEG format achieves smaller file sizes by discarding information. Look for a camera that lets you choose the highest-quality JPEG mode when you need it, or that has an optional mode for storing in a higher-quality format like TIFF.

For more information about storage formats, *see also* Part III.

✔ **Do I want the maximum amount of flexibility in choosing resolution?**

Most medium-priced cameras offer a choice of resolutions. You can elect to use 640 x 480-pixel resolution when you want to take a lot of pictures for an application (such as a Web page) that doesn't require the ultimate in sharpness. Then switch to ultra-sharp mode when you snap a picture that you'll want to print out.

✔ **What resolutions should I look for?**

Cameras generally label their resolution choices with names like Standard, Fine, Superfine, Ultrafine, and so forth. A typical range in a multimegapixel model might look like this:

- **Standard:** 640 x 480 pixels

- **Fine:** 1024 x 768 pixels

- **Superfine:** 600 x 1200 pixels (with medium JPEG compression)

- **Ultrafine:** 1600 x 1200 pixels (with low JPEG compression)

- **Hi-Res:** 1894 x 1488 pixels

Choosing Storage

Your camera's built-in storage determines how many photos you can take at one time at a particular resolution, and often determines the method you'll use for transferring them to your computer. For information on various storage and picture transfer options, *see also* Part III.

Here are the questions you should ask yourself:

✔ **How many pictures do I want to take in one session?**

The more pictures you take before you can download them to your computer, the more storage you'll need. High-resolution color pictures consume more storage than low-resolution or black-and-white images.

✔ **Do I need removable storage?**

Most cameras in the medium price range and above accept removable storage devices such as CompactFlash or SmartMedia cards. If you take only a few pictures at a time and are willing to link your camera to your computer every time you copy them, a camera with a fixed amount of built-in memory can do the job at a lower price.

✔ **Which removable storage do I need?**

CompactFlash and SmartMedia cards are the most common. Sony's Memory Stick and floppy disk options let you share storage among several devices. Some new devices such as Iomega Clik! and Imation LS-120 disks offer especially low-cost, high-density storage.

✔ **What's the easiest way to copy pictures to my computer?**

You can insert removable storage devices directly into a PC Card adapter, floppy disk drive, or other compatible device in your computer. You can also attach an external reader. Your camera can also link to your computer through a serial or USB (Universal Serial Bus) cable.

Evaluating Exposure Controls

Digital cameras all have automatic exposure features for both flash and non-flash photography, but some are more flexible than others. For more information on using flash, see Part IV. Here are a few questions to ask yourself when choosing a camera:

✔ **Can I take low-light pictures without flash?**

Low-light pictures call for a more sensitive sensor. Camera specs often provide the equivalents to conventional film speeds, measured in ISO (International Standards Organization) ratings such as ISO 100, ISO 200, and ISO 400. The higher the number, the more sensitive the sensor.

✔ **Can I compensate for backlit or frontlit pictures?**

Intermediate and advanced cameras may have a simple provision for departing from the standard exposure determined by the camera's sensor. For example, you may be able to vary the exposure to compensate for subjects that are strongly backlit (that is, an unimportant background is very bright in comparison to your subject matter) or front lit (the background is very dark) so the exposure is determined by your actual subject, rather than an overall average of the scene. A typical backlit scene is shown in the figure that follows.

✔ Are exposure modes provided?

Cameras may have exposure modes fine-tuned for particular kinds of picture-taking sessions, such as sports, portrait, and landscape photography. You can dial in one of these and improve the quality of your pictures effortlessly. See Part VI for more information about taking pictures of a particular type.

✔ Is there a spot meter?

A *spot meter* zeroes in on a particular, small area of the image and determines the exposure from that, ignoring the rest of the picture. This feature can be handy when you take many pictures in difficult lighting conditions and would like to specify which area of the picture is used to determine exposure.

✔ Can you set the exposure manually?

Cameras that allow setting the lens f-stop manually may also let you choose either a mechanical shutter (like the one found on conventional cameras), an electronic shutter, or both. The ability to choose a shutter speed offers creative control when you want to, say, stop fast-moving action under low light levels.

✔ Can I combine manual and automatic exposure control?

You may want to use a particular shutter speed or lens opening
for creative reasons, such as to stop action, or provide selective
focus. Intermediate and advanced cameras may allow you to
choose a priority for automatic exposure control. That is, you
set either lens opening *or* shutter speed, and the sensor deter-
mines the other automatically.

✔ Can I get the range of flash exposures I need?

Camera vendors typically provide a recommended flash range
that offers well-exposed pictures. For example, you may be
advised to shoot between 2.5 to 12 feet for pictures at a wide-
angle setting, but only up to 8 feet in telephoto mode. If you
take pictures requiring a particular flash range (such as sports
or close-up photography), check the recommended settings for
your camera carefully. See Part VI for more information about
taking pictures of a particular type.

✔ Can I determine when the flash is triggered?

Most cameras allow you to choose from automatic flash,
always-on flash, always-off flash, and other modes.

✔ Can I use an external flash unit?

Built-in flash is fine for snapshots, but if you're shooting por-
traits and want to use multiple lights, or need a high-powered
flash for sports photography, being able to couple an external
flash to your camera is great. Look for a connector (usually a
device called a "hot shoe") that can mount an external flash or
connect to one positioned elsewhere.

Selecting an LCD Viewfinder

The latest digital cameras generally have both an optical
viewfinder, which you can use to quickly frame an image, and an
LCD display screen on the back of the camera for more precise
composition and picture review. Here are some of the additional
factors you should look at when evaluating your camera's LCD
viewing system:

**✔ Is the camera's LCD screen visible in daylight and cold
temperatures?**

The brightness of the LCD screen can vary from camera model
to camera model. Some may be almost invisible in daylight.
Look for a bright screen, especially one with some sort of built-
in shading provided by the camera for easier viewing. If you
take many photos in cold weather, make sure the LCD operates
under chilly conditions — some do not.

✔ **How large is the LCD screen?**

LCD screens are a mass-produced component available from a relatively few number of companies, so you won't find as wide a variation in sizes as you might think. Most measure about two inches diagonally. A larger LCD screen is usually easier to view than a smaller one, particularly if the larger display is also brighter.

✔ **How much power does the LCD screen consume?**

You usually won't find any indication of how much power the LCD screen consumes, but rest assured that the LCD screen, especially if it is lit from behind (backlit) is a major drain on your camera's battery. The best option is found in some of the latest digital cameras, which use a TFT (thin-film transistor) active matrix display that provides a bright image that's illuminated by the same sunlight that is the bane of backlit displays.

Selecting an Optical Viewfinder

When you want to put your camera up to your eye rather than hold it in front, away from your face, an optical viewfinder is the most convenient option. Here are some questions to take into account:

✔ **Where is the optical viewfinder located?**

A traditional window-type viewfinder provides a slightly different view from what the lens sees, which can result in clipping off part of an image. A viewfinder that is located directly above the lens eliminates clipping on either side of the image. Placing the viewfinder as near as possible to the taking lens reduces the tendency to chop off the tops of heads.

✔ **Do I shoot many close-ups?**

A single-lens reflex (SLR) camera provides a view of your subject through the same lens used by the sensor, giving you a much more accurate preview (similar to that seen by the LCD screen). If you take many close-ups and want more convenient viewing than a camera-back display, an SLR camera may be your best choice.

✔ **How bright is the view?**

Both window-type and SLR optical viewfinders can vary in brightness, depending on the method used to present the view. If you take pictures in low light conditions, you want the brightest view possible. See Part IV for more information.

✔ **Does the viewfinder provide camera-status feedback?**

Many cameras include red, green, and yellow LEDs in the viewfinder to inform you of things such as when the camera is ready to take the next picture, whether too little light exists to take a picture without a flash, and other information. If you keep a camera glued to your eye while snapping off shots, a viewfinder display of info is better than having to check the top or back of the camera for this information.

✔ **Can the viewfinder be adjusted for eyeglass-wearers?**

Some cameras have built-in diopter correction (like that found in binoculars) that you can use to adjust the view for near-and farsightedness. With such an adjustment, you won't need your glasses at all to see the viewfinder image clearly.

✔ **Is the view clear when wearing glasses?**

The physical design of the viewfinder may also limit how well you can see the entire field of view when wearing glasses. A ridge or bezel around the viewport and the amount of magnification provided may prevent someone wearing glasses from seeing the entire subject area.

Thinking About Other Features

All else being equal, you may want to look at some other cool features found in digital cameras before making your final selection. Here are some of them:

✔ **Can I record sound?**

Adding a voice message can be a great way of annotating your images. Some cameras have built-in speakers and can record 3 to 10 seconds of sound in audio formats compatible with both PCs and Macs.

✔ **Can I output to a TV?**

Many digital cameras have NTSC and PAL-format video outputs so you can view your pictures on a TV screen without transferring them to a computer. This option is great for previews and can turn your camera into a portable slide projector!

✔ **Are high-capacity rechargeable batteries available?**

Digital cameras use a lot of juice. A set of alkaline batteries may be good for only a dozen pictures, or fewer if you use the LCD screen a lot. The best digital cameras can use or are furnished with rechargeable NiCd (nickel-cadmium). Even better are lithium or NiMH (nickel metal hydride) batteries, good for 20–30 or more pictures between charges.

Getting the Most from Your Lens

Whether your digital camera has a fixed focus, fixed focal-length lens or versatile zoom optics, you can use the characteristics of your lens creatively. Digital camera lenses have three attributes that you can put to work: the focal length (zoom setting), the aperture (the size of the opening that admits light to the sensor) and the focus.

This Part details techniques for using your lens's zoom settings to change focal length, using the aperture settings to change exposure and put selective focus and depth of field to work, and avoiding problems with the distortion that telephoto and wide-angle lenses can cause

If you want to learn more about getting the most from your digital camera's lens, pick up a copy of *Digital Photography For Dummies*.

In this part . . .

Aperture Settings

The aperture settings of a lens determine two things:

- ✔ How much light is admitted to the sensor during the exposure time

- ✔ How much of an image is in focus

The larger the lens opening, the more light admitted, but, at the same time, the range in which your subject is its sharpest (in focus) is reduced. Smaller lens openings cut down the amount of light, but increase this zone of sharpness, also called depth of field. Most of the time you'll want to let your digital camera determine the aperture settings, but if your camera allows making manual adjustments, you can use this lens setting creatively.

Changing apertures to adjust lightness/darkness

Your camera's exposure meter may provide an exposure suitable for the overall average illumination of a scene. You may want to make a picture lighter or darker to change the look or for an artistic effect. If you want more information about lighting, *see also* Part IV. To change the aperture setting, also called the f-stop, follow these steps:

1. Set your camera to Manual mode or Aperture Priority mode.

 In Manual mode, you must set both the aperture and shutter speed yourself. In Aperture Priority mode, you can set the aperture and the camera will adjust the shutter speed to provide the correct exposure.

2. To make a scene brighter, use the aperture control to select a smaller f-stop number.

 The smallest lens opening is typically f/22 or f/16; the largest may be f/2 or f/1.4. Each number increment admits twice as much light as the last one. A typical array of f-stops from smallest to largest is f/22; f/16; f/11; f/8; f/5.6; f/4; f/2.8; f/2; f/1.4. You may also find markings for in-between f-stops, such as f/3.5 (halfway between f/4 and f/2.8).

3. To darken a scene, use the aperture control to select a larger f-stop number.

Bracketing exposures with the lens aperture

Bracketing is taking a series of pictures, each with a slightly differ-
ent exposure, to see how the different photos vary from a creative
standpoint. This method is shown in the figure that follows. One
easy way to do this effect is to expose each using a different f-stop,
as described here.

1. Set your camera to Manual mode. Don't use Aperture Priority
 mode; if you do, your camera will adjust the shutter speed and
 the exposures will all be equivalent.

2. Take a picture at the lens setting you or your camera's expo-
 sure meter have determined to be ideal.

3. Open up the lens (use a smaller number) one f-stop and take a
 second picture.

 Bracketing using increments smaller than one f-stop often
 won't produce results that look much different from picture to
 picture.

4. Open up one more f-stop and take another picture.

5. Move the aperture setting control back to the original ideal setting set in Step 2, then close down the aperture (choose a larger number) by one f-stop.

6. Take a picture.

7. Move the aperture setting to the next larger number and take the final picture.

You have exposed five pictures at five different f-stops. Usually this range is enough to produce all the useful exposure variations.

For more information on exposure, *see also* Part IV in this book, Lighting It Just Right.

Focus and Depth of Field

Focus is the distance from your camera at which your subject appears sharpest. Anything located significantly in front of or behind the focus point appears to be less sharp. The zone of sharpness is called *depth of field,* and varies depending on how far you are from your subject and the size of the lens opening. At any given zoom setting, the larger the lens opening the smaller the zone of sharpness will be. You can adjust both the focus and lens opening manually to change a picture's depth of field.

Adjusting focus manually

You can focus your lens manually to select what portions of the image will be sharp. You need one of two things in order to do so:

✔ A through-the-lens viewing single-lens reflex (SLR) camera.

✔ The LCD panel on the back of your camera to judge focus.

Once you have one of the preceding, follow these steps:

1. Set your camera to Manual Focus mode.

2. View the subject through your SLR viewfinder or by using your LCD screen.

3. Adjust the focus using your camera's focus control and take the photo.

Traditional cameras change focus with a ring around the barrel of the lens. Digital cameras (which may not even have a lens barrel as such) may use a knob or sliding control.

Adjusting focus automatically

Even with your camera set on automatic focus, you can still determine what areas of the picture are sharpest by using this technique:

1. Look through the viewfinder and move close to your subject so that only the portion you want sharpest is shown.

2. Press the shutter release button down halfway and hold it, to lock in the current focus setting.

3. Move back and frame the picture you want.

4. Press the shutter button the rest of the way to take the picture.

Adjusting depth of field with the aperture

Focusing the camera determines the position that is sharpest. You can use the aperture to increase or decrease the zone in front of or in back of the focus point to make more or less of your subject sharply focused, as shown in the figure that follows.

For information on using selective focus, *see also* Part V.

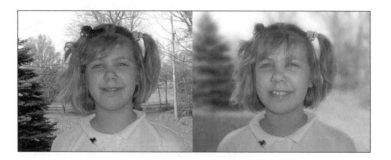

To adjust the depth of field with the aperture:

1. Set your camera to Manual Aperture mode or Aperture Priority mode.

2. To reduce the depth of field (focus zone), open the lens (use a smaller f-stop number).

The wider the lens opening, the less depth of field.

3. To increase the depth of field, close the lens (use a larger f-stop number).

4. If you are in manual mode, adjust the shutter speed to compensate for the additional or reduced exposure that results from changing the f-stop.

Optimizing sharpness

Your lens is only one of several factors that determine how sharp a picture is. If you must have the sharpest picture possible, follow these steps for adjusting your lens, shutter speed, and other controls:

1. Set your camera to Manual mode.

Use the highest resolution setting and lowest compression ratio available for your camera, usually referred to as Fine or UltraFine mode. For more information on resolution and compression ratios, *see also* Part I.

2. Set your lens to its sharpest f-stop.

Lenses will generally provide their sharpest images at two to three f-stops smaller than wide open. The very smallest f-stops provide additional depth of field, but the overall sharpness of the image will be reduced.

3. Use the highest (shortest) shutter speed you can, such as ¹⁄₅₀₀th or ¹⁄₁₀₀₀th second.

Obviously, if you want to use a particular f-stop you may not be able to choose the shortest shutter speed. You may instead want to increase the amount of illumination (if possible) with extra lights or electronic flash so you can use the optimal lens opening.

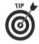

Electronic flash units have a built-in, very rapid shutter speed because they fire for a brief instant of time.

4. If you are not using a very short exposure time, mount the camera on a tripod.

5. Focus carefully to make the most of your available depth of field.

6. Press the shutter button gently.

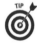

You may want to use the self-timer to let the camera carry out this step smoothly and vibration-free.

Lens Accessories

Lens accessories can provide creative tools that improve your photographs. They range from simple devices like lens hoods to close-up lenses, filters, and special-effects devices.

Attaching a lens accessory

Depending on your camera model, you may find no provision at all for attaching a lens add-on; you may have to use only the accessories provided by your camera vendor; or you may be able to use any standard lens accessory available to fit a variety of cameras. The following techniques are used to attach most kinds of lens accessories:

1. If your lens has no accessory mounting fittings at all, you may still be able to use filters and some add-ons by holding them or taping them onto the front of the camera.

 This method is very clumsy but can work if you have no other recourse.

2. Your lens may have a special accessory mount on the front that you can use to attach lens accessories offered by the camera vendor.

 The camera may, indeed, require special accessories to work with its lens or zooming capabilities.

 Some intermediate and all higher-end digital cameras use standard lens accessory mounts.

 Typical sizes include 38mm, 49mm, and 52mm diameters. You can find a wide variety of lens add-ons at photo and video stores that fit this kind of mount.

Shading your lens with a lens hood

Lens hoods improve the quality of your pictures by blocking extraneous light outside the picture area. This light can reduce the contrast of your image, or provide glare (including the familiar starbursts caused by sunlight and other bright light sources). To work effectively, select a lens hood that closely matches the field of view of the lens it will be used with. Cameras with removable lenses (usually found on only the very high-end models) ideally need a different lens hood for each lens. Here's how to choose a lens hood like the one shown in the figure that follows:

1. Determine what type of lens you're using:

Telephoto lens: Assuming your camera does not provide a lens hood (or offer shading through its design), you can improve your pictures with a lens hood.

Wide-angle lens: Less prone to flare and other defects caused by extraneous light, but can still benefit from a lens hood.

2. Decide on a hood that is wide enough to admit all the light needed for the widest zoom setting.

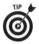

Otherwise, you'll see dark corners (called *vignetting*) caused by the lens hood itself appearing in the photo. If you see this effect, remove the lens hood and obtain a wider one.

Remember: If you first mount other accessories, such as filters, on a lens and then add a lens hood, the field of view of the hood will be smaller, which can cause vignetting.

Moving in with close-up attachments

Close-up attachments are a way to move in even closer to subjects than your camera's close-up setting will allow. They are typically designated by the amount of magnification provided: +2, +3, and so forth, and are attached to your camera lens using the same mount as a lens hood.

1. Select and mount the close-up attachment that provides the size magnification you want.

2. Use your camera's LCD display screen or through-the-lens viewfinder to frame your photograph.

3. Focus very carefully using manual focus controls.

 Note: A camera's autofocus system may not work with add-on close-up gear. *see also* "Adjusting focus manually" earlier in this chapter for more information.

4. Adjust to a small f-stop.

 Remember: Smaller f-stops have the larger numbers.

 Depth of field is much lower at close-up distances.

5. Press the shutter button carefully.

 Subject movement is also more apparent up close. Mount the camera on a tripod if you can; doing so can steady the camera during exposure and keep it from moving and spoiling your focus setting.

Working with close-up attachments that fit between the lens and camera

Cameras with removable lenses (usually the high-end models) can use a second type of close-up attachment, which fits between the lens and the camera. This kind of attachment consists of either a

✔ Series of rings that form a sort of extension barrel to the camera

✔ Bellows-like device or extension ring, like the one shown in the figure that follows, which offers varying distances

The farther away the lens moves from the camera, the greater the magnification.

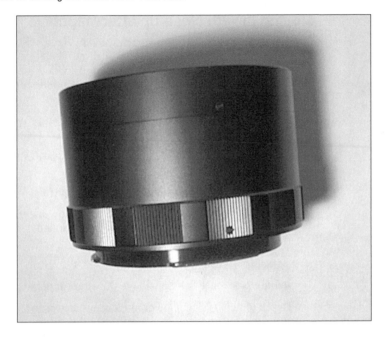

1. Mount the extension rings or bellows on the camera.

2. Mount the lens on the accessory.

3. Use your camera's LCD display screen or through-the-lens viewfinder to frame your photograph.

 Moving the lens farther from the camera also moves the aperture farther away, reducing its size. A camera's built-in through-the-lens exposure meter should compensate.

4. As with all close-up photography, focus very carefully.

 The simplest way to focus is to move the camera closer and farther away from the subject after you get the approximate magnification you want.

Changing images with filters

Digital cameras have less need for filter attachments than conventional film cameras. Traditional filters are used to provide color correction for light sources; that is, to correct for sunlight at dusk that is too reddish, or sunlight on a snowy day, which may be too blue. A digital camera's white balancing provision should correct for this kind of defect automatically. Other filters provide special hues and effects, especially for black-and-white photos. For example, a yellow filter can darken a blue sky in a black-and-white

image, providing dramatic contrast with clouds. You may still want to use filters for special effects, such as the following:

✔ Use a color correction filter to warm up or cool off a picture without fiddling with the white balance control. For example, you may want a slightly reddish filter to make a sunset even more red than usual, or add a slightly blue filter to a snowlit scene.

✔ Underexposing an image while adding slight blue filtration can simulate nighttime. Stop down (change to a smaller aperture) several f-stops and use the blue filter.

✔ Split-color filters (red on top, blue on the bottom, blue to clear, or some other combination of colors) can provide an interesting effect by coloring everything above and below the horizon differently.

✔ White-balancing may not compensate completely for the vagaries of fluorescent lights (particularly those that are not rated as "daylight" models). Fluorescent filters can color-correct for such lighting.

Cutting glare with a polarizing filter

A polarizing filter, which works as described below, can cut down glare that reflects off shiny surfaces outdoors, such as glass and chrome, as you can see in the figure that follows.

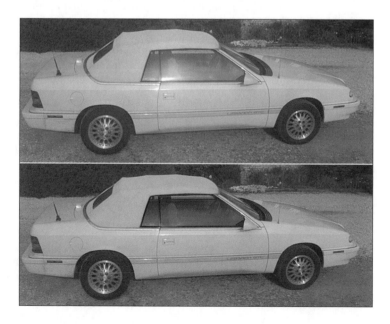

To use a polarizing filter:

1. Move so that the light is at your back or over one shoulder.

 Polarizing filters work best when the sun comes from this angle.

2. Take these actions depending on what kind of viewfinder you have:

 • **Through-the-lens viewfinder or LCD display:** Rotate the filter until you can see that the glare has been eliminated.

 • **Window-style optical viewfinder:** Hold the filter up to your eye and rotate it until you see the glare disappear.

3. Note the angle of the filter, then mount it on your lens, and then rotate it until it is arranged in the same orientation.

Adding special effects with add-ons

Conventional film cameras have available a huge array of special effects add-ons that can work their magic on digital pictures with any camera that can accept them. Among your choices:

✔ **Diffusion filters:** Provide a soft effect that's excellent for flattering portraits.

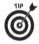

You don't have to buy a diffusion filter: a plain glass filter smeared with a little petroleum jelly, or even a nylon stocking held in front of the lens can provide a similar effect.

✔ **Fog filters:** Add a fog effect to your images.

✔ **Neutral density filters:** Cut down the amount of light drastically letting you, for example, use a wide lens opening and/or slow shutter speed for artistic effect even in bright daylight.

✔ **Star-effect filters:** Add starbursts or sunbursts to your pictures.

✔ **Split-field diopters:** Are actually filter-like add-ons that have a close-up lens on half the glass's surface, and plain glass on the other, a little like bifocal eyeglasses. You can use these devices to produce two fields of focus, one very close and one very far away, in a single picture.

Lens Care

Because your lens is your sensor's "eye," be careful to keep it clean and free of scratches. Most digital cameras have covers that protect the lens when the camera is off, but it's still easy for moisture, dust, or fingerprints to mar the surface.

Avoiding problems

The best way to take care of your lens is to avoid problems in the first place. Follow these steps:

✔ Always turn off your camera when not in use.

 While most digital models shut themselves off after a few minutes if not actively used, the lens cover may not be retracted.

✔ Keep your fingers away from the lens. Oily fingerprints are your lens's worst enemy.

✔ Don't let rain or snow fall on your camera's lens. The moisture will blur your pictures, and even the cleanest precipitation contains dust picked up from the atmosphere.

✔ Avoid smoky environments, if possible. Smoke can coat your lens quicker than dust!

If you must work in a dirty or wet environment, you can mount a plain glass filter, or a so-called *skylight filter* on the front of your lens to protect it. Many photographers who use expensive cameras leave these on their lenses all the time, as they are easier to clean than the lens itself, and if the filter gets scratched or damaged it can be easily and cheaply replaced. With a digital camera that hides its lens behind a cover between uses, this may be unnecessary.

Cleaning your lens

At one time, virtually all lenses were made of optical glass, which was relatively soft to allow it to be ground into the proper shape. Such glass was easily damaged. Hardening coatings, plastic lenses, and glass covers over the actual lens has reduced the potential for damage. However, you should still be careful when cleaning the inevitable fingerprint smudges and dust spots.

1. Remove as much dust as possible by blowing on the lens with an air bulb, syringe, or canned air supply. Waft the airflow at an angle to remove the dust from the lens.

2. Brush the lens surface lightly to remove stubborn dust that remains.

Use a clean lens brush made for that purpose or roll up a piece of lens-cleaning tissue and tear off one end to create an ad-hoc brush, as shown in the figure that follows. Ordinary facial tissue or cloth may be too hard or contain lint that will just dirty your lens again.

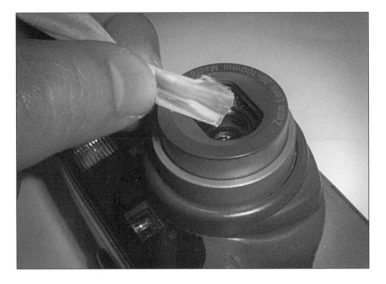

3. If you still see dust, breathe on the lens and brush the dust from your lens a little more vigorously. A little moisture can prevent the dust particles from scratching the lens surface.

4. When all else fails, you may have to use special lens cleaning fluid. Place just enough lens fluid on a piece of lens cleaning paper and stroke gently to remove the fingerprint or other stubborn dirt.

Don't use window cleaner or other liquids that may leave a residue.

Zooming In and Out

Using a digital camera's zoom lens is a convenient way of framing the exact picture you want without the need to move closer or farther away from your subject. Cameras can accomplish this feat by magnifying or reducing the actual image by either

🖛 Moving the elements of the lens (optical zoom)

🖛 Cropping the picture so only the pixels from a smaller area are used to form the image (digital zoom)

The figure that follows shows an image at maximum and minimum zoom settings.

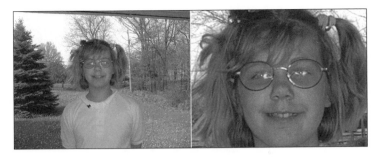

Enlarging an image with zoom

You can zoom in closer to crop a picture tightly, removing any extra area from the photo:

1. If your camera offers both optical and digital zoom, use the camera's optical zoom control first — usually a double switch marked W (for wide-angle) and T (for telephoto) to zoom in.

 Optical zoom provides better quality, so you should use it first. If it provides enough zooming, you can skip the digital zoom entirely.

2. After using the optical zoom (if any), zoom in further with the digital zoom control.

3. If your camera is set on manual focus, recheck focus.

 see also "Adjusting focus manually" earlier in this chapter.

 Because the lens elements move in an optical zoom, the point of exact focus can change slightly as you zoom in or out; refocus as necessary after changing zoom magnification.

Reducing an image with zoom

Zooming out enlarges your area of view to provide a wider angle. To reduce an image by zooming, follow these steps:

1. Use either optical or digital zoom controls to zoom out.

2. If your camera is set on manual focus, recheck focus.

 see also "Adjusting focus manually" earlier in this part.

3. If your camera is set for automatic exposure, check to see whether the overall scene is much lighter or darker than when the lens was zoomed in.

Because the camera's exposure meter may take into account the entire scene, the exposure may change. If you want to lock auto exposure in on the zoomed subject, press the shutter button down part way before zooming out.

Minimizing telephoto distortion

A telephoto lens, which magnifies the image, can introduce apparent distortion in two ways:

✔ The distance between subjects appears to be compressed.

✔ Subjects may appear to be wider than they are at normal and wide-angle settings (as you can see in the figure that follows).

Examine your scene, then take one of the following corrective measures:

✔ If objects seem to be compressed together that you'd prefer to be shown separated, move them farther apart before shooting.

✔ Alternatively, you can manually open your lens wider to separate the main subject from others in the foreground and background using selective focus.

✔ Reduce your zoom setting until you achieve the look you want, then enlarge the finished picture.

Note: The distortion produced by telephoto and wide-angle lenses is only apparent distortion. It's not caused by the lens but by the distance between the camera and the subject. If you enlarged the center portion of a wide-angle picture to provide the same field of view as a telephoto picture, the enlarged picture would have the same compressed look.

Minimizing wide-angle distortion

Wide-angle lenses also can provide apparent distortion, actually caused by moving the camera very close to the subject. At close range, objects that are much closer to the camera (such as a human's nose) appear to be much larger than they should be compared to objects that are farther away (such as ears), as you can see in the figure that follows. Because of this, the tele setting can provide more flattering pictures of humans than wide-angle settings.

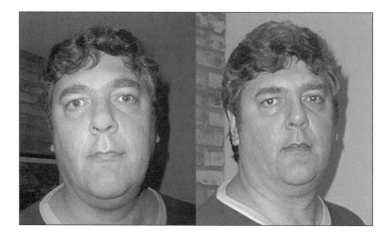

Examine your scene, then take one of the following corrective measures:

- ✔ If objects, such as buildings, seem to "fall away," it's because you've tilted the camera. Try to keep the back of the camera parallel with the subject. If necessary, step back so you can include the whole subject in the frame without tilting.

- ✔ If objects very close to the camera look large and out of proportion, step back slightly. Zoom in a little to keep the same image size, if you want.

Choosing and Using Storage

The type of storage media that a digital camera uses is determined by the camera itself: Virtually all digital cameras can use only the variety of media they were designed for. Each alternative has some advantages: Some storage types are less expensive, more compact, or easier to transfer to a computer. Particular cameras may offer several different ways to transfer pictures to a computer, however, so you have choices when it comes time to move your photos to your computer.

In this part . . .

Choosing Storage Media

The time to choose which kind of storage media you will rely on is when you select your camera. Run through these checklists and consult the table to help make your decision.

Estimating the amount of storage you'll need

1. If your camera offers a choice of resolutions, evaluate the proportion of large (high-resolution) photos (1024 x 768 pixels and up) you will take compared with small (low-resolution) pictures (640 x 480). For more information on resolution, *see also* Part II.

The more high-resolution photos you take, the more storage space you'll need. Many cameras can store 12–16 high-resolution pictures in 8MB of storage, twice that many at medium resolution, and as many as 100 pictures at a low-resolution, 640 x 480-pixel setting.

2. If your camera allows you to choose between uncompressed and compressed storage, make an educated guess as to how often you'll need maximum quality, uncompressed pictures.

You may be able to store only a half dozen or fewer uncompressed photos with 8MB of storage, but you will be able to enlarge them in your computer without significant loss of detail.

3. Estimate the frequency with which you'll be able to move pictures from your camera and its storage media to your computer or alternative storage media.

If you take a great many pictures with no nearby access to a computer to download them (as on, say, a vacation, or during a major picture-taking session), you'll need more storage capacity for your camera (the equivalent of carrying extra rolls of film for a conventional camera).

4. Using the factors in Steps 1–3, make a very rough estimate of how much storage you'll need at any given time. Figure .75MB for pictures at resolutions higher than 1024 x 768 pixels, .5MB for pictures at 1024 x 768 pixels, and .08MB for pictures at 1024 x 768 pixels.

Resolution	Number of Photos	× Size Per Photo	Megabytes Required
More than 1024 x 768-pixels			.75MB
1024 x 768-pixels			.5MB
640 x 480-pixels			.08MB
Total megabytes of storage required			

Comparing alternatives

1. Keeping in mind the storage requirements you roughed out in the preceding section, decide how important cost of storage media is to you.

Some types of storage media, such as floppy disks or SuperDisks, are very inexpensive compared with alternatives like CompactFlash or SmartMedia.

2. Evaluate how important size of the storage media is to you.

Storage options range from barely postage-stamp sized to media the size of 3.5-inch floppy disks.

3. Choose from among the storage alternatives from the following table.

Storage type	Pros	Cons
Camera's built-in nonremovable storage	Comes with the camera	Can't be expanded
SmartMedia	Smallest removable media; available in 64MB or larger sizes	More expensive than floppy disk; SuperDisk media
CompactFlash	Almost as small as SmartMedia; available in variety of sizes to 128MB or larger	More expensive than floppy disk; SuperDisk media
Floppy disk	Very inexpensive	Large size; relatively low capacity
SuperDisk	Less expensive than SmartMedia or CompactFlash for 120MB of storage	Large size; requires SuperDisk drive in your computer

cont.

Storage type	Pros	Cons
Tiny hard disk	Largest capacity (340MB and up); very small size	Expensive
Sony Memory Stick	Compact; can be used in other devices, such as MP3 players	Locks you in to Sony components
Iomega Clik	Compact, inexpensive	Still not widely used
PC Card (PCMCIA)	Can be read directly by notebook PCs	Only a few digital cameras use them

For more information on digital camera storage options, see *Digital Photography For Dummies.*

Connecting a Serial Port Adapter

Some digital cameras are furnished with a *serial port cable,* a connector used to transfer pictures from the camera to your computer. While using a serial connection is slower than a Universal Serial Bus (USB) link, this method has the advantage of working with all Windows-based computers because every one has a built-in serial port. For information on USB, see the next section in this part.

1. Plug the serial port cable into your camera.

The port will usually be clearly marked, and often looks like a small headphone jack. You may have to lift up a hinged door or cover that hides the port and protects it from dust and moisture.

2. Locate a serial port on your computer that matches the connector on the other end of the cable.

The serial ports on a Windows computer (usually two of them) are always male. That is, they contain pins that fit into matching holes on the serial cable's connector. The ports come in two varieties, both shaped roughly like the letter D, as shown in the following figure.

The most common port is roughly ¾ of an inch across and has nine pins. Older computers may have a larger serial port (about 1½ inches across) with 25 pins.

Don't confuse a 25-pin serial port connector with the similar 25-pin parallel port (printer) connector. The printer port is always female.

3. Plug the camera's serial cable into your computer's serial port.

4. If you want to leave the cable attached to your computer, you can tighten the thumbscrews found on the connectors of many serial cables.

Connecting a Universal Serial Bus (USB) Adapter

An increasing number of digital cameras are furnished with a Universal Serial Bus (USB) cable. This kind of linkup is much faster than a standard serial cable, and is compatible with most recent Windows 95/98, Windows 2000, and Macintosh computers.

Windows NT 4.0 does not support the Universal Serial Bus. If you use this operating system, you can't use a USB cable to link your camera and computer, even if your computer does have a USB port. To connect your camera into a USB port:

1. Plug the USB port cable into your camera.

As with serial ports, the port is usually clearly marked and is usually a flat female connector, identical in appearance to the USB port on your computer. The USB cable, which is the same at both ends, is shown in the following figure. You may have to lift up a hinged door or cover that hides the port and protects it from dust and moisture.

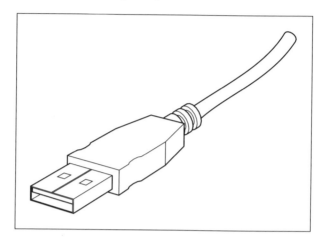

2. Locate a free USB port on your computer.

 You'll find your computer's USB port(s) on the back of your computer, or under a cover on the back or side (usually two such ports exist). You may also find a USB port in a hub, which is an external device connected to your computer that has USB ports of its own. Hubs can be stand-alone devices or may be included in other computer peripherals, such as a monitor.

3. Plug the USB cable into your computer.

 Both ends of the USB cable are identical, so it doesn't make any difference which end you plug into the computer, and which end into the camera.

Storing Images on CompactFlash Cards

CompactFlash cards are small memory chips that can store 4MB to 128MB of information — or more (higher capacity disks are developed all the time). To use a CompactFlash card:

1. Locate a compatible CompactFlash card.

 CompactFlash cards come in only one physical configuration and are clearly marked with their capacity, as you can see in the following figure.

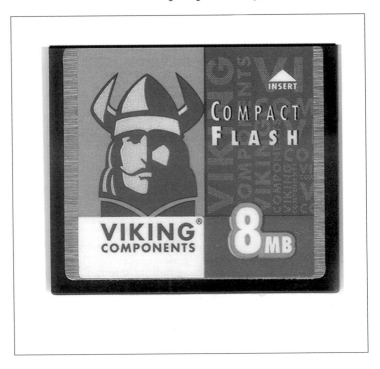

2. Insert the disk into the CompactFlash slot on your digital camera.

 The slot may be covered by a flip-in door that retracts when you begin to insert the card. One edge of the card has two rows of tiny holes (which accept the connector pins inside the camera). Insert that end into the camera first. If the card is facing the wrong direction, it will only go in half way; reverse it and try again.

3. To remove the disk, press the button found near the card slot on your camera.

 The card will pop out part of the way. You can grip it and slide it completely out of the camera.

4. To copy the pictures from the card to your computer, place the card in the card reader attached to your computer.

 Card readers are often external devices connected to your computer by a USB, parallel, or serial cable. The card reader has a slot similar to the one in your camera that accepts the CompactFlash or SmartMedia card and provides a link to your

computer. If your computer has a PC Card slot, you can pur-
chase a PC Card adapter that accepts a CompactFlash card,
and then fits in your computer's PC Card slot.

Storing Images on Floppy Disk

Sony pioneered the use of ordinary floppy disks for image storage
with its Mavica line of cameras. Floppy disks have the advantage of
being very inexpensive, and are readable by any computer with a
floppy disk drive, which includes virtually all Windows PCs, and
Macintosh models prior to the iMac line. Newer Macs may require
an add-on external floppy disk drive. To use a floppy disk:

1. Locate a compatible floppy disk.

 The most common floppy disks in use today are 3.5 inches
 wide and hold 1.44MB of information. Similar-looking disks in
 use ten years ago hold only 720K to 800K of information. If you
 think you might have one of these rare birds, you can differen-
 tiate them from 1.44MB disks by the fact that they don't have
 the square hole found in the upper-left corner of the newer,
 high-density disks, as you can see in the following figure.

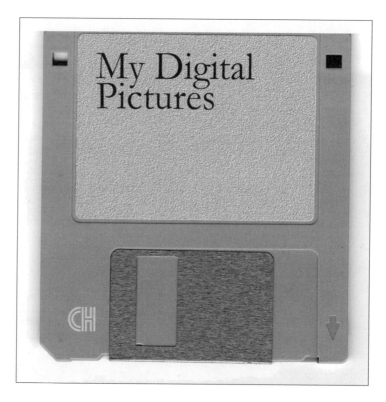

2. Make sure the disk is not write-protected.

 Notice a square cutout in the upper-right corner of the disk (when you're looking at the label). When the hole is covered by its sliding plastic cover, the disk can be written to. If the cover is moved up to reveal the hole, the disk is write-protected, and it cannot be written to.

3. Slide the disk into the slot on the side of your camera until it clicks in place.

 While you can try one of eight different ways to try to insert a floppy disk into its slot, only one of them will actually work. If you feel some resistance when you try to insert the disk, you're probably orienting the disk the wrong way. The edge with the metal slide always goes in first.

4. To remove the disk, press the button on the side of the camera until the disk pops out a short way and then remove the disk.

Storing Images on Mini Hard Disks

IBM has pioneered digital camera storage using tiny hard disk drives that are scarcely larger than CompactFlash cards. Although Casio was the first company to introduce a camera using the IBM MicroDrive, these 170 to 340MB-drives are compatible with a growing list of cameras (from Canon, Fuji, Kodak, and others) equipped with the new CompactFlash+ Type II slot. To use a mini hard disk:

1. Locate a compatible IBM MicroDrive.

2. Insert the drive in your camera's Compact Flash+ Type II slot.

3. To remove the card, press the Eject button and pull it out.

4. Use your computer's card reader with a CompactFlash-to-PC Card adapter to copy the photos from the tiny hard drive, using the software provided with your camera.

Storing Images on PC Cards

A few digital cameras use the original removable solid-state media, ATA Type II PC Cards (originally known as PCMCIA cards). These cards are larger than CompactFlash, SmartMedia, or Memory Stick media, but can be read directly with any computer (such as a notebook) with a PC Card slot. To use this type of card:

1. Locate a compatible ATA Type II PC memory card, like the one shown in the following figure.

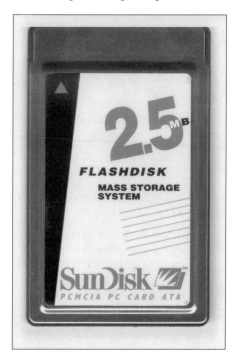

2. Insert the card in your camera's PC Card slot.

3. To remove the card, pull it out. Press the camera's Eject button if necessary.

4. Copy pictures to your computer using your computer's PC Card slot, or reader and the software supplied with your camera.

Storing Images on SmartMedia Cards

SmartMedia cards are slightly smaller than CompactFlash cards, but have similar capacities. To use a SmartMedia card:

1. Locate a compatible SmartMedia card.

 Like CompactFlash, SmartMedia cards come in only one physical configuration, and are clearly marked with their capacity, as shown in the following figure.

2. Insert the card into the SmartMedia slot on your digital camera.

 SmartMedia cards have one corner cut off, as shown in the figure above, making it simple to tell how the card is oriented.

3. To remove the card, press the button found near the card slot on your camera.

 The card will pop out part of the way. You can grip it and slide it completely out of the camera.

4. Copy the pictures to your computer using your SmartMedia card reader, and the software supplied with your camera.

External card readers are available for both CompactFlash and SmartMedia cards. Some external card readers can even read both types. You can connect them to your computer using USB, parallel,

or serial cables. SmartMedia adapters are also available to allow reading these cards in computer equipped with a PC Card slot.

Storing Images on Sony Memory Sticks

About the size of a stick of chewing gum, Sony Memory Sticks provide 32MB (or more) of storage for Sony's upscale (professional and semi-professional) digital camera line. Sony has also applied the technology to camcorders and music players, so if you end up with a camera that uses Memory Sticks, you can share them among any of these other devices. To use a Memory Stick:

1. Locate a compatible Memory Stick.

2. Make sure that the Erasure Prevention Switch (the only switch on the Stick) is turned to the position shown on the Stick as "off."

 Erasure Prevention protects your images from accidental deletion.

3. Insert the Memory Stick into its slot on your camera.

 Memory Sticks have an arrow that points in the direction the Stick should be inserted into your camera. In addition, one corner is clipped off the rectangular Stick to help you determine the correct orientation. You won't be able to insert the Stick in the wrong way.

4. To remove the Memory Stick, press the button near the Memory Stick slot to eject the Stick.

5. Copy pictures to your computer using the card reader supplied with Sony cameras that use Memory Sticks, using the software supplied with your camera.

Storing Images on SuperDisk LS-120

Imation SuperDisks, which resemble a thick floppy disk, have the advantage of storing almost ten times as much information — 120MB in all. If your camera is furnished with a SuperDisk slot, you'll also need to have a SuperDisk drive (which can also read conventional floppies) connected to your computer. To store an image on a SuperDisk:

1. Locate a compatible SuperDisk.

2. Make sure the disk is not write-protected.

 As with floppy disks, notice a square cutout in the upper-right corner of the disk (when you're looking at the label). When the hole is covered by its sliding plastic cover, the disk can be written to. If the cover is moved up to reveal the hole, the disk is write-protected, and it cannot be written to.

3. Slide the disk into the slot on the side of your camera until it clicks in place.

 Like floppies, you can try to insert a SuperDisk in its slot every which way, but only the correct way will be successful. While you can try one of eight different ways to insert a floppy disk into its slot, only one of them will actually work. If you feel some resistance when you try to insert the disk, you're probably orienting the disk the wrong way. The edge with the metal slide always goes in first.

4. To remove the disk, press the button on the side of the camera until the disk pops out a short way, and then remove the disk.

 SuperDisk drives are available for internal installation in Windows PCs using the same IDE interface used for hard disks and CD-ROM drives. Other models are available for connecting to a PC's parallel port, to a Universal Serial Bus port (required for Macintoshes), or to a PC Card (PCMCIA) slot such as those found in notebook computers.

Transferring Pictures through Infrared Connections

Some digital cameras, including several models from Kodak and Hewlett-Packard, have infrared ports, like the one shown in the following figure, that allow them to beam picture information directly to printers and computers. If you have a camera like this, follow these steps:

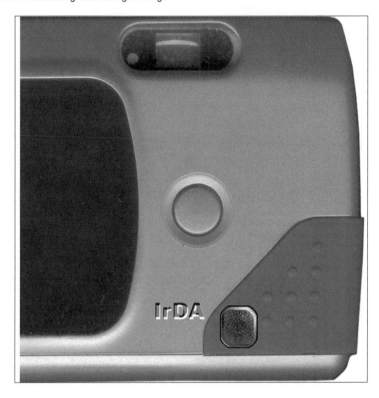

1. Use your camera's controls to set it for infrared image transfer.

2. Place the camera so its infrared window is pointed toward the infrared sensor of the receiving device.

 The closer that you can position the two devices to each other, the better. Most newer laptop computers and some printers (especially those from Hewlett-Packard) have an IrDA (Infrared Data Association) infrared sensor. You can also purchase an add-on infrared port for desktop computers and laptops that don't have this capability.

3. Start the transfer, using the transfer software for your camera that you've previously installed on your computer.

Lighting It Just Right

Awell lighted photograph can make the difference between a triumphant prize-winning image and a photo fiasco destined for the digital dustbin. The secret to lighting success is knowing that the kind of light you use is just as important as the amount. Taking a picture with plenty of light and having disappointing results is possible, and capturing a striking image in the dimmest surroundings is just as possible.

The chief tools in your arsenal will be existing light indoors and out (neither of which have to be used as is), as well as artificial light of the electronic variety. You find some techniques in this part for optimizing your results in any lighting situation.

In this part . . .

Existing Light Indoors

Existing light is the illumination already present on the scene — usually daylight outdoors, or any lighting (lamps or candles) present in an indoor location. In many cases, indoor lighting is quite enough to let you take good digital pictures. The results can be more pleasing and less harsh than flash pictures, with illumination that fills the entire scene. If you have a choice, here's how to make the most out of the kind of light you're using.

Taking a basic indoor photo

If you want to take an indoor photo by existing light instead of flash, follow these steps.

1. Use your digital camera's controls to switch your electronic flash from Automatic to the Off setting.

2. Change your camera's sensitivity setting to its maximum.

Most digital cameras have sensors that are roughly as sensitive as ISO 100 film. Some offer multiple settings, typically ISO 100, 200, and 400. Using the most sensitive setting, such as ISO 400, lets you capture better pictures in dim light.

3. If your camera has manual exposure controls, choose a lens opening and shutter speed combination that will provide the best picture in low light.

The widest lens opening (the smallest number, such as f/2 or f/1.4) admits the most light to the sensor, at the cost of a little sharpness and reduced field of focus. However, don't use the widest aperture if it means using a shutter speed so slow that you'll get shaky pictures.

For more information on working with lens settings, *see also* Part II.

4. If the light seems very dim, use a tripod to steady the camera during the exposure.

A tripod serves a double purpose: It protects the camera from jitters caused by the normal hand tremble everyone has, and when used with a self-timer, isolates the camera from the jarring that can happen when you punch the shutter button.

5. If you're using manual focus, focus very carefully.

At wide lens openings, not as much of your subject will be in sharp focus, as you can see in the figure that follows.

6. When you're ready to take the picture, gently squeeze the shut-ter button to avoid jarring the camera.

7. Wait a second or two after you think the picture has been taken, in case the camera is using an exposure time that's longer than you expected.

For most people, holding a camera with a steady hand for an expo-sure of one-half or one second is impossible, but many people can get good pictures with "long" exposures of ⅓₀ or ¹⁄₁₅ second.

Taking an indoor picture with overhead lighting

You'll find overhead lighting in offices, gymnasiums, or even homes. Follow these special tips when taking pictures in these environments:

✔ **If you have a choice, take the picture in an area with diffused overhead fluorescent lighting rather than harsh spotlights.** The effects are worse when ceilings are rather low, say eight to ten feet, and less pronounced with higher ceilings.

✔ **If ceilings are low, have your subjects sit down.** When light comes from overhead, subject matter much closer to the ceiling (such as people's heads) receives much more light than objects only a few feet lower (for example, things they are holding in their hands) as you can see in the following figure.

✔ **Be sure to position yourself at eye-level with human subjects, particularly if one or more have thinning hair, to avoid emphasizing the tops of their heads.**

Arguably the worst possible shooting environment is a group portrait of bald men in a room that's brightly lit from overhead!

Supplementing available light

When shooting pictures indoors, you'll want to use as much available light as is available. The following tips can help you supplement the light at hand:

✔ **Remove lampshades to double or triple the amount of light available.** The unshaded light bounces off the wall or ceilings to reach more of the room. The light can be a little harsh, so don't position your subjects too close to them, and keep the lamps out of the picture area.

✔ **Open the drapes or blinds to let daylight in.** Keep in mind that much more light is close to the window than elsewhere in the room, so either use the window light as your main light source (position the subject near the window), or move the subject away from the window and keep the window out of the picture area.

✔ **Use any reflective surfaces available to increase the amount of light on your subject.**

✔ **Place a white cardboard sheet near a window to help bounce light into a room.** Having a few white-shirted bystanders standing next to the photographer can also amazingly fill in dark shadows with a little reflected light.

✔ **Use your tripod and let your self-timer take the picture to make the most of the available light and a slow shutter speed.**

Taking an indoor portrait with window lighting

Window lighting is soft and flattering, and can make the best lighting for portraits. Here are some tips on how to use it effectively:

✔ **Choose a window that doesn't have direct sunlight pouring in.** For example, windows facing north are often the best. An east-facing window is okay late in the afternoon. A window facing west is okay in the morning.

✔ **Position your subject in a comfortable position, facing the window.** Seated or standing positions are equally good as long as the subject is relaxed. The subject doesn't need to look directly at the window: A three-quarter view (that is, halfway between a profile and facing the camera full on) may look best. But the window should provide the main illumination.

✔ **Use reflectors or supplementary lighting to soften the shadows.** Even dark shadows cast by window illumination will have soft edges and may not be objectionable. A reflector can be anything you have on hand. You can position a white piece of cardboard or even just someone wearing a white shirt or blouse to bounce some of the window light into shadow areas.

✔ **Take several pictures from different angles to explore the possibilities of window illumination, as shown in the following figure.**

Existing Light Outdoors

Outdoors, the quantity of light will rarely be a problem; however, you can always improve the quality with a few simple techniques.

Taking a picture on an overcast day outdoors

At dusk, on cloudy days, or during one of those pesky solar eclipses, outdoor illumination can be as dim as you'll find in many indoor locations. The following tips can help you improve your photos:

- ✔ **If your camera allows adjusting its sensitivity, change to the highest setting, typically ISO 400.**

- ✔ **Use the best f-stop and shutter speed combination for the amount of light admitted and action-stopping shutter speed that your manual exposure settings allow.**

- ✔ **Use wider apertures (smaller numbers such as f2 or f1.4) and a shutter speed of at least ¹⁄₆₀ of a second, then slow down the shutter speed to ¹⁄₃₀ or ¹⁄₁₅ of a second to squeeze out the last bit of exposure.**

- ✔ **Use a tripod, especially if it will let you use a smaller f-stop (larger numbers, such as f4 or f5.6) to improve focus and sharpness.**

Taking a picture at dusk or dawn

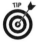

Pictures at the beginning or end of the day can be particularly difficult, and differ quite a bit from low-light outdoors photos on overcast days. Use these tips to make the best of the situation:

- ✔ **If your camera allows adjusting its sensitivity, change to the highest setting, such as ISO 400.** After the sun sets, you'll have a real need for the most sensitive setting.

- ✔ **Watch carefully for shadows and the harsh light that can be caused by the low-lying sun.**

- ✔ **Change your subject's position, if possible, or use fill flash or reflectors to soften the light, as shown in the following figure.** You'll find more about fill flash and reflectors later in this part.

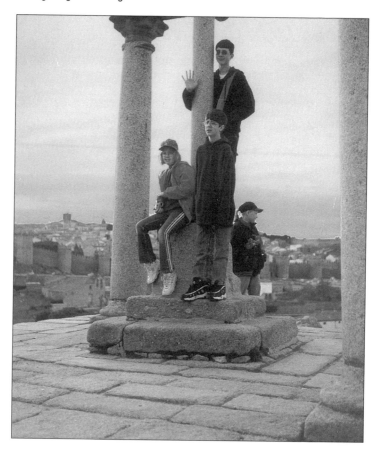

✔ **Unless you're taking a picture of the sunrise or sunset itself, use your camera's white-balance features to compensate for the reddish light found at dusk and dawn.** You can also use a filter to adjust for the light, but you may want to simply let nature take its course and appreciate the warm glow pictures that pictures taken at this time of day have. For information about using the white-balance feature of your camera, see your camera's instruction manual.

Taking a time exposure

Time exposures are pictures you take by having the camera shutter open for several seconds. They are a good tool for pictures made in very low light, or for when you want the kind of special effects and blurring that only a time exposure can provide. Usually, only more advanced cameras offer this option. If you have this sort of camera, follow these steps:

1. Set your camera for a time exposure.

 Cameras provide time exposures in several ways:

 - Some have settings built right in for lengthy exposures: 1 second, 10 seconds, 30 seconds, and so forth.

 - Others have a T (time) or B (bulb) setting that opens the shutter when you press the button and closes it when you release the button or press it a second time.

 - You may need to use a device called a cable release that screws into a receptacle on the shutter release.

 - Electronic cameras may also have a solid-state control, either wired or wireless, that you can use to make time exposures.

2. Mount the camera on a tripod, table-top clamp, or other secure foundation that will hold it steady for the long exposure.

3. Set the f-stop for the picture. If you're just trying to make a picture in low light, set the f-stop for a relatively wide opening (use the smaller numbers, such as f/2 or f/1.4). If you want the longest exposure possible (for example, to provide time exposure blur effects) use a smaller f-stop (the larger numbers, such as f/16 or f/22).

4. Set your exposure. Some cameras may accurately determine exposure automatically during a long exposure. For others, you may have to estimate. Start out by using an exposure time of several seconds, then double it until the picture as seen on your LCD preview screen starts to look the way you want it to.

5. Use a cable release, remote control, or your self-timer to trigger the exposure.

 An over-the-lens neutral density filter cuts the amount of light passing through your lens so that you can take time exposures even in fairly high light levels. You can find neutral density (ND) filters in camera stores.

Taking a picture in bright sunlight

 Even with lots and lots of sunlight, lighting is not all hunky-dory because outdoor illumination can be very harsh — especially on the beach or in snow scenes. Try these techniques:

 ✔ **In bright daylight, try to position yourself so your subject is lit from the front. However, if you're photographing a person, take care that your subject is not staring directly into the sunlight (as shown in the following figure).**

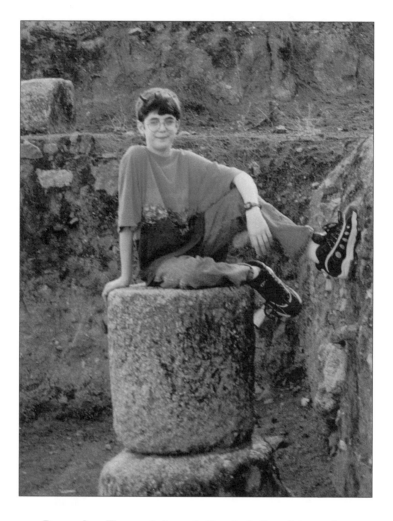

Remember: The sun is lower in the sky in the winter and at dusk, so having the sun directly behind you can lead to squinty subjects.

- ✔ **Avoid positions that cause dark shadows to obscure faces or important parts of your subject.**

- ✔ **If you can, position subjects so they're illuminated by the soft diffused light of the shadows of a tree or building.**

✔ **Don't try to capture detail in both shadowed areas (for example, under a tree) and brightly lit areas in the same photograph.**

✔ **Wait until a cloud passes in front of the sun to provide softer, more flattering light for human subjects.** Slightly overcast days are even better!

Flash Indoors

If not enough light exists to take a picture indoors, electronic flash can be a lifesaver. Here are some techniques for getting the most from artificial illumination indoors.

Taking a basic flash picture

Use the following techniques to get good indoor flash pictures:

✔ **Get fairly close to your subject, typically 6 to 12 feet away.** The flash on most digital cameras has only enough light for pictures taken in that range. As much as you love your favorite singing group, don't try taking their picture from the 40th row at a concert! However, some units have more powerful flashes. Consult your user manual to find out the recommended minimum and maximum distance.

✔ **Keep your subjects at about the same distance from the camera.** If one subject stands four feet from the camera and the second one is eight feet from the camera, the second subject will receive only one-quarter as much illumination (not half!). If you have a choice, keep your subjects in the same plane as much as possible when using flash.

✔ **Use accessory flash if your camera allows it.** An accessory flash unit provides more flexibility. You can purchase a more powerful flash unit than the one built into your camera.

✔ **Watch for reflections and move if necessary to reduce or eliminate them.** When using existing light, you can usually see reflections before they become a problem. However, your flash can bounce off eyeglasses, windows behind the subjects, and other bright surfaces. You can sometimes change angles so the flash isn't pointing directly at an object that will reflect into the lens, or switch to existing light, as you can see in the following figure.

✔ **Check to see whether all your subjects had their eyes open during the exposure.** Before you take the picture, ask them to notice when you take the picture whether the flash appears to be red or white. If they saw a red flash, the light passed through their eyelids because they were closed. Reshoot!

Taking a picture with an accessory flash

Using an *accessory flash* — a flash that's not built into your camera — has many advantages, such as more flexibility in lighting your subject and the reduced possibility of getting red-eye effects. Here are the steps to take to get the best picture with accessory flash:

1. Connect your accessory flash to your digital camera.

Most cameras that accept an accessory flash have a connector called a "hot shoe." You can mount the flash directly on the hot shoe to connect it electrically with the camera's flash-firing system. You may also be able to connect an accessory flash to a digital camera through a cord and a flash connector or a hot shoe adapter.

2. Set the accessory flash to its Automatic mode, or adjust the exposure manually using the settings dial or calculator mounted on the back of the flash.

3. Point the accessory flash to illuminate at your scene.

If the flash is pointed directly at your subjects, having it mounted a foot or two above the camera reduces the chances of red-eye effects, plus causes any shadows to fall behind the subject rather than directly on a wall that might be behind, as you can see in the following figure.

4. For a softer effect, point the flash at a wall or the ceiling.

The warnings about overhead illumination in the previous section, "Taking an indoor picture with overhead lighting" apply here, as well. Be cautious when bouncing flash from low ceilings. Some flash units have a small window that sends some light forward even in bounce mode to provide more even illumination.

Working with multiple flash units

For more advanced lighting effects, try using more than one flash, like the pros do; just follow these steps:

1. Connect one flash to your digital camera.

 This may be the camera's built-in flash and is usually the flash unit with the lowest light output. You can use more powerful accessory flashes to create a stronger lighting effect from other angles.

2. Connect your additional flash units to an electronic device called a *slave*.

 Slave triggers are available at camera stores. They have a built-in photoelectric eye that detects the light from the flash connected to your camera and triggers the slave units instantaneously.

3. Position one flash at an angle to provide a main light. For portraits, an angle of about 45 degrees works well, with the flash slightly raised.

4. Use another flash at a lower power as fill. The main flash on your camera can do this job, or you may want to use a second external unit. It should be set to a lower power setting so it won't overpower the main flash.

5. Optionally, set additional flash units to provide background illumination behind the subject, or a bit of extra light on the hair.

 These auxiliary lights can be difficult to aim correctly; use them only if you have electronic flash with incandescent modeling lights that provide a preview of what the electronic flash will illuminate.

6. Soften the light of the accessory flash units by pointing them into photographic umbrellas or bouncing them off white cardboard sheets.

 You can buy white rain umbrellas, like the one shown in the following figure. Photo stores also sell special white, metallic silver, and metallic gold umbrellas (these cost more than consumer umbrellas, obviously) Be cautious when using colored reflectors! A gold-toned umbrella or reflector can provide flattering results, but avoid using greens and blues at all costs.

7. When you take the picture, allow enough time between shots to let all the flash units recycle to full power.

 Time the slowest flash and use that as your benchmark. The other flash units won't mind "waiting."

Flash Outdoors

When there's not much light, electronic flash can help you get good pictures; however, even outdoors, when you may think there is plenty of light, electronic flash can provide even more flattering illumination.

Using flash outdoors on a bright day

Fill flash — flash used in conjunction with available light to supplement rather than replace it — can add extra detail to pictures that might otherwise be washed out. For more on setting your camera to provide fill flash, see the next section. Just use these tips:

✔ **If your subject has harsh, inky shadows, use your camera's manual Always-on or Fill Flash mode.** The flash illumination will supplement the sunlight, mostly filling in the shadows. This technique works especially well on very sunny days, or in scenes with a lot of contrast, such as at the beach or on ski slopes.

✔ **To soften the flash illumination, place a piece of facial tissue over the flash window (but not the lens).** A piece of facial tissue will cut down on the amount of flash delivered to your subject so it doesn't overpower the sunlight and eliminate shadows entirely. If you take a picture outdoors and find you have a dark background, your flash is too bright, as shown in the following figure.

Using flash outdoors on an overcast day

Flash can brighten up outdoor pictures on very dark, overcast days. You get the best results if almost enough light exists to make a picture without the flash. If the outdoors is truly dark, your photos will end up looking like nighttime flash pictures, with inky black backgrounds.

If the flash overpowers the daylight illumination, producing dark backgrounds, balance the amount of daylight with the amount of flash so that the two light sources complement each other by using these techniques:

✔ **If your flash allows reducing its power, try cutting it to half or quarter power.** Try fooling an automatic flash that accepts film speed settings by dialing in a higher ISO number so that it thinks your digital film requires a different amount of exposure. For example, you can use ISO 400 instead of ISO 200 when setting your flash to reduce the amount of flash, or to ISO 100 instead of 200 to increase the amount of flash delivered.

✔ **Reduce the amount of flash illumination delivered by placing tissue over the flash window.** Make sure the flash is in manual exposure mode. An automatic flash won't be fooled by this technique and will simply deliver more light.

Flash Settings

Your camera probably has, at least, the first three of these flash settings, and may have the last two. Here's how to choose between them:

✔ **Use Auto Flash mode to let the camera set exposure for you.** The camera's exposure meter (or the exposure cell in an accessory flash) examines the scene and triggers the flash if enough light isn't available. Advanced units even measure the amount of light bouncing back from the subject and adjust the level of flash illumination emitted to compensate for the darkness or lightness of your subject.

✔ **Use Manual Flash/Fill Flash mode to have the flash always go off.** In this mode, the flash always is triggered, even if plenty of light is available. Use it when your scene has some dark shadows you want to brighten. Advanced cameras and accessory flash units may let you choose the amount of light using full power, half-power, quarter-power, or other settings.

✔ **Use No Flash mode to prevent the flash from firing.** You can use No Flash mode even in low illumination. Use this setting to preserve the lighting effect of the original scene. Perhaps your subject is seated next to a candle, and a moody, dimly lit picture is what you want. Turn off your flash, and grab that image!

✔ **Use External Flash mode to replace or supplement your internal flash.** Some more expensive digital cameras may have a connector to plug in an external electronic flash, like the one shown in the following figure. You can use this accessory flash instead of your camera's built-in flash, or to supplement it.

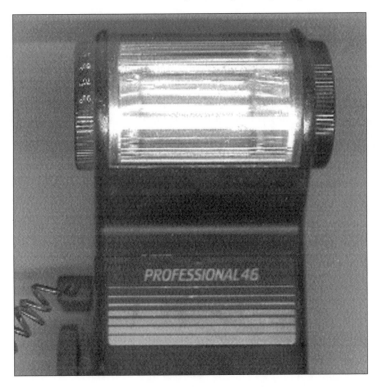

✔ **Use Red-eye Reduction mode when photographing people, particularly in dark areas.** Red eyes, those orange or red pupils caused by light reflecting from a subject's retina back into the camera, can be reduced (but not always eliminated) by a feature in some digital cameras. In this mode, the flash fires twice: once to cause the irises of your subject's eyes to dilate, making them smaller and less prone to producing red-eye when the "real" flash fires a fraction of a second later.

Getting the Right Exposure

After you've chosen your lighting, you need to make sure your exposure — the amount of light reaching the camera's sensor — is correct. Some cameras, particularly higher-end models, may let you set the exposure manually. Most of the time, the automatic exposure setting does a great job for you.

Locking in automatic exposure

Even if your camera has automatic exposure (which sets the exposure for you) built-in, you need to make sure that the camera knows exactly what subject matter you want to expose for. With most cameras, you want to follow these steps:

1. **Frame your picture.** Examine the composition to see whether any very bright or very dark areas exist that could fool the camera's exposure meter. If so, step in close and reframe, or recompose, so that only the area you want exposed correctly is shown in the viewfinder.

2. **Press the shutter button down halfway and hold it there.** This action causes the camera to set the exposure based on what's shown in the viewfinder; then lock it in. If you've stepped in closer to frame your most important subject matter, that's what the exposure will be based on.

3. **With the shutter button still held down, check your composition a final time.** If you moved in close to zero in on part of the image, you may have to take a step or two back to reframe the entire composition.

 For more information on composition, *see also* Part V.

4. **Press the shutter button the rest of the way down to take the picture.**

Setting exposure manually

Digital cameras generally do a very good job of determining exposure automatically. More advanced models may have sophisticated metering programming controls that examine parts of a scene, determine which parts are important, and emphasize the portions that need the most light. However, as you get creative with photography, you may be tempted to manually set the exact exposure needed for a particular effect.

You may value the ability to guess the rough exposure in standard situations, either as a reality check to make sure that your camera's exposure meter is functioning correctly, or in case you're forced to wing it without a meter for some reason. Here's how to calculate exposure by guesstimate:

✔ In average sunlight, the exposure will be f16 at the shutter speed closest to the ISO setting of your digital camera.

 That is, f/16 at $\frac{1}{250}$ of a second at ISO 200, and f/16 at $\frac{1}{500}$ of a second at ISO 400.

✔ On the beach or under snowy conditions, use a shutter speed half as long, or an f-stop that is half as large.

Instead of f/16 use f/22, or instead of $\frac{1}{250}$ of a second, use $\frac{1}{500}$ of a second, and so forth, as was done for the photo that follows.

✔ When the sky is slightly overcast, use a shutter speed that's twice as long, or an f-stop that is twice as large.

Instead of f/16 use f/11; instead of, for example, $\frac{1}{250}$ of a second, use $\frac{1}{125}$ of a second, and so forth.

✔ In an average office or classroom, at ISO 400 use $\frac{1}{60}$ of a second and f/2.8.

Adjust the exposure proportionately for higher or lower ISO settings.

Setting exposure manually with a light meter

Professional photographers still use hand-held light meters (which measure the amount of light present) for critical work, even though sophisticated built-in meters do a wonderful job under most conditions. Some meters calculate an exposure based on the overall scene; others, called *spot meters,* zero in on only a small portion of the scene. Averaging meters are further divided into the reflective type (you point it at the scene) and incident (you move it to the subject area and point it at the light source). Here's how to determine exposure with a hand-held light meter:

✔ **With a reflective light meter that averages an entire scene, point at the subject matter.**

Adjust the exposure if you visually judge the scene to have a higher proportion of dark or light tones than an average scene: for example, a dark or light background.

✔ **Point a reflective light meter at your hand or other skin area receiving the same amount of light as your subject.** For light-colored skin, cut the exposure in half; for dark skin, double the exposure reading.

Light meters assume that an average scene reflects 18 percent of the light falling on it (never mind how the figure was arrived at). Light-colored skin reflects twice that much light; hence, you need to double the exposure (use a larger f-stop or longer shutter speed). Conversely, darker skin reflects half as much, so you need to halve the exposure (use a smaller f-stop or a shorter shutter speed).

✔ **Hold an incident light meter next to the subject so it receives the same illumination, and use that exposure.**

Incident meters are the ones with the white domes covering the light sensor, like the one in the following figure. The dome simulates an 18 percent gray value, so you can generally use the exposure value it provides directly.

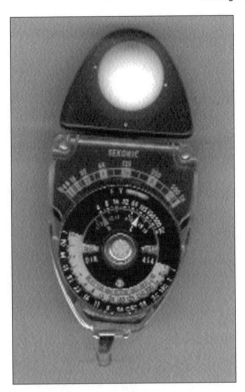

 Electronic flash meters are also of the reflective or incident types (some meters incorporate both standard and flash modes) and you can use them in the same way.

Exposing a back-lit scene

Back-lit scenes are those that have a bright background or a strong light source behind the subject. Use one of these techniques:

✔ Move in close and take a light reading of the subject directly. Hold down the shutter button, back up, and take the picture.

✔ If using a manual exposure, get close to your subject, point the light meter at the subject (or point an incident meter towards the camera), and use that reading.

✔ If you're using automatic exposure, use your camera's back-light setting or an override switch (labeled something like –2) to show that it will provide two f-stops more light.

Back-lit scenes, like the one shown in the following figure, can look great if exposed properly.

Lighting Portraits

Many common picture-taking situations, such as portraits, can benefit from standard lighting techniques that you can then modify creatively. Here are some of the standard portrait situations you'll often work with.

Lighting a portrait with available light

Portraits aren't especially tricky to light, but you'll want flattering illumination to make your subjects look their best. Here are some tips to follow:

✔ **Arrange the subject in a comfortable pose.** Have the subject turn slightly to one side or another and look at the camera. Straight-on portraits look like mug shots!

✔ **Try to arrange the lights so that three-quarters of the subject's face is fully lit and one-quarter is in shadow.** This technique is called *broad lighting*. You can also use the reverse arrangement for dramatic effect; this technique is called *short lighting,* as you can see in the following figure.

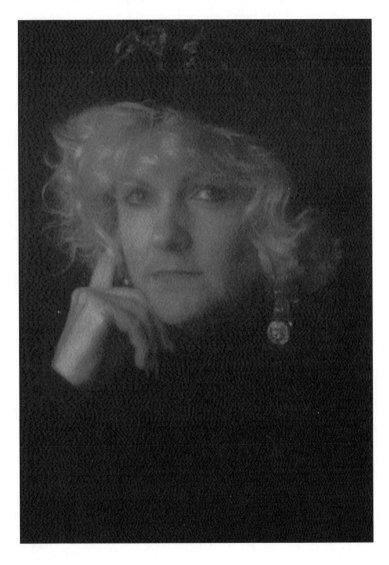

✔ If the portion of the face in shadow is too dark, use some auxiliary lighting or arrange to have some light reflect into the shadows. For more information on using auxiliary lighting, ***see also*** Part IV.

✔ **Use soft light (reflected light) where possible instead of harsh direct light.**

✔ **Arrange to have some light behind the subject shining on the background so that the subject won't blend in.**

Lighting a portrait with electronic flash

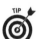

Flash is trickier to work with, but when used properly, can make your subject look good. Just use these tips:

✔ **Arrange the subject in a comfortable pose, as described in the preceding section.**

✔ **If you're using only your camera's built-in flash, you may want to soften it a little using a handkerchief. For more information on softening light with a handkerchief,** *see also* **Part IV.**

✔ **With a single accessory flash, point the flash at a white umbrella, piece of white cardboard, or other reflective material to soften the light.**

✔ **If possible, use several flashes to provide light that gently sculpts the shape of the face (as opposed to flattening it head-on with a single direct flash). For more information on using several flashes,** *see also* **Part IV.**

Lighting a portrait in sunlight

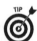

Here are a couple tips for taking a portrait in sunlight:

✔ **Pose your subject out of harsh sunlight: under a tree, in the shadow of a rustic building, or a similar area.** Don't include very bright areas in the same picture; your exposure may be wrong or the photo too contrasting.

✔ **Pose your subject so some bright light outside the shadowed area provides some highlights.** You want soft light, not bland light.

Composing Great Pictures

Picture composition is nothing more than arranging your subject matter, either by physically moving the subjects around (as you often can with people) or by changing your point of view. In some situations, such as at sports events, you won't be able to dictate how the subjects are arranged, nor change your point of view much. In that case, good composition relies on waiting until your subjects are arranged in a pleasing way and then snapping the picture at the best moment.

Although the art of composition has rules, they are only guidelines. Your instincts and creative sense will tell you a good time to break those rules and come up with an unusual, eye-catching picture.

In this part . . .

Conceptualizing Your Photo

Take some time to visualize your photo before you begin the actual picture-taking process. You don't need to spend hours dwelling over your photo, but you at least need to have a general plan in mind before starting to shoot. Select your subject matter, center of interest, and how the picture will be oriented first.

Planning your picture

Random snap-shooting can sometimes yield interesting results, but you'll end up with more pleasing photos if you stop to think about what kind of picture you want before you ever put the viewfinder up to your eye. Ask yourself these questions:

✔ **What kind of picture do I want to take?**

Will your photo be a portrait, a sports action shot, or a scenic masterpiece? The kind of picture you want to take affects where you stand, how easily you can set up the picture, and other aspects of composition. For example, to shoot a close-up, you may want to use a tripod so that you can frame the picture tightly and lock in your composition. For a sports picture, you may want to get a high angle or one from a particular location to suit the composition you have in mind.

✔ **How will the photo be used?**

If you plan to print the picture in a publication or enlarge it, you want a tight composition to maximize sharpness. If you want to use the shot on a Web page, you may want to step back and take in a little extra and crop later with your image editor because resolution isn't as critical for Web graphics.

✔ **Whom am I shooting the picture for?**

You'll compose a photo created for your family differently from a photo that your colleagues or strangers will view. Your family may like a picture better if the composition revolves around that cute new baby. Colleagues may want to see a product highlighted or the CEO shown in a decisive pose.

Choosing your subject matter

Well composed pictures should be simple and uncluttered, and without a bewildering excess of detail. Here's how to examine your subject for excess busy-ness:

✔ Will my photo picture many objects, or just a few?

If shooting many objects that are similar, consider singling out a few of them for emphasis. Do you really need a picture of a whole pile of pumpkins, or would a photo of just one of them, like the following figure, be more interesting?

✔ Will my photo show something viewers will care about and want to look at?

A pile of sand is boring; a sand dune can be graceful and beautiful. A swarm of ants can be featureless, but a close-up of two soldier ants from opposing anthills might be fascinating. Select your subject matter carefully.

✔ Can my photo make a statement about something that goes beyond the picture itself?

Instead of simply photographing a poor child, show how a poverty-stricken youth can still be happy or ambitious. Some of the best photographs take a stand and say something.

Composing through the viewfinder

Most of the time you'll feel most comfortable composing your picture through the optical viewfinder. Follow these steps to line up the shot:

1. Make sure that you can see the entire viewfinder area.
 Depending on the magnification of the image in the viewfinder, you may be able to see the whole viewing area with your eye a half-inch or more behind the eyepiece — or you may have to put your eye right up to it.

2. If necessary, remove your glasses and adjust the viewfinder's diopter setting. If you have to remove your glasses to see the entire viewfinder, it may be difficult to see the subject. Many intermediate and advanced cameras have a viewfinder diopter adjustment, like those found on binoculars, that let you at least partially correct the viewfinder for your vision needs.

3. Keep in mind that the viewfinder usually shows less than what you get. Even single-lens reflex models often provide an image that is slightly larger than what you see through the viewfinder. If the exact borders of your image are important, you'll have to crop within your image editor, as you can see in the following figure.

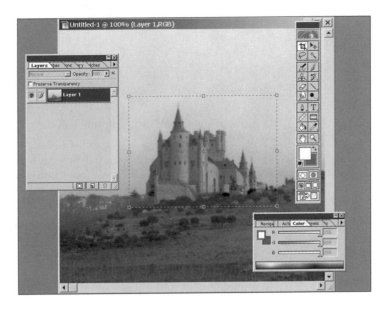

4. Allow for parallax when shooting close-ups. Non-through-the-lens optical viewfinders don't see exactly what the taking lens sees, particularly when you shoot close-ups. Look for lines at the top (and sometimes at the side) that indicate the upper or side limits of the picture area when taking a close-up picture.

Choosing a center of interest

Photographs shouldn't send the person looking at them on a hunting expedition. As interesting as your subject may be to you, you won't want viewers puzzling over what's the most important part of the image. So, every picture should have a single, strong center of interest. Try these techniques:

✔ **Find something in the photograph that the viewer's eye should concentrate on, forming a center of interest.** Usually, your center of interest will be a person, group, or the object you're seeking to highlight. You don't want eyes roaming around your photo searching for something to look at. Some aspect should jump out and grab their attention.

✔ **Make sure that your center of interest is the most prominent object in the picture.** Certainly, you may think your Aunt Mary is a worthy photo subject, but if she's standing next to an outlandish custom-painted automobile, she may not even be noticed.

✔ **See that the center of interest is either the brightest object in the photo or at least is not overpowered by a brighter object.** Gaudy colors or bright shapes in the background will distract viewers from your main subject. Eliminate them, move them behind something, or otherwise minimize their impact.

✔ **Make sure only one center of interest is in your composition.** Other things in a photo can be interesting, but they must clearly be subordinate to the main center of interest. A child seated on the floor playing with a puppy would be interesting. But other puppies in the photo should be watching or vying for the child's interest, not off somewhere else in the photo engaged in some distracting activity.

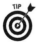

More than one center of interest is confusing. If you really have several things of importance in a single picture, consider taking several separate photos of each and using them to tell a story. Or, group them together to form a single, new center of interest.

✔ **Avoid putting the center of interest in the exact center of the photograph.** Move the important subject to either side and a little toward the top or bottom of the frame. Don't take center literally. See the following figure for an example of a center of interest moved to one side.

Choosing subject distance

Choosing the distance to stand from your subject is one of the first things to do, but it's not something you do once and then forget about. As you take pictures, constantly examine your distance from the subject and move closer or farther away if adjusting your position will improve the composition. Here's how to choose a subject distance:

- ✓ **To convey a feeling of space and depth, move back a bit or use a wide-angle lens.** Standing back from your subject does several things. The foreground area becomes more prominent, adding to the feeling of space. You'll also take in more of the sky and other surrounding area, giving additional depth.

- ✓ **Make sure that your subjects don't appear too small when you're moving back; they should still be large enough to be interesting.** Moving too far back is the most common mistake amateur photographers make. If you're showing wide-open spaces in your picture, be certain that it's because you *want* to.

- ✓ **For photos that emphasize a person, group of people, or a particular object, move in as close as you can.** A close-up viewpoint adds intimacy and shows details and textures of a subject that can't be seen at greater distances, as you can see in the following figure. A short telephoto setting is often the best route to getting closer; with a normal or wide-angle lens, you may get some apparent distortion of objects that are very close.

🖊 For more information on using wide angle and telephoto settings, *see also* Part II.

🖊 **Move so you fill the frame completely with interesting things.** Whether you're shooting close up to your subject or at a distance, your composition should not include anything that isn't needed to make the picture. Full frames mean less enlargement and sharper pictures, too.

Choosing orientation

You don't see many square pictures; they tend to be static-looking and not very interesting unless a square frame is used cleverly, for example, with subject matter that is also square. Most pictures are composed using a vertical (tall) or horizontal (wide) orientation.

Digital cameras are built with a horizontal layout, the better to fit into our hands. However, too many photographers never take anything but horizontally composed pictures. By turning your camera 90 degrees in either direction, you can frame a great-looking vertical shot. Use these techniques when choosing between horizontal and vertical formats:

✔ **If you're taking pictures for a slide show or, more likely, for a computer presentation, stick with horizontally composed pictures.** Slide show images are seen sequentially and should all have the same basic frame that is often sized to fill up the horizontal screen as much as possible. Inserting a vertical picture may mean that the top and bottom of your photograph is cut off.

You can still have a vertically composed picture in your slide show; just mask off the right and left sides in your image editor to produce a vertical image within the fixed-size horizontal frame.

For more information about image editing, *see also* Part VII, "Editing Images."

✔ **If your subject has dominant horizontal lines, use a horizontally composed image.** Landscapes and seascapes with a prominent horizon, photos of sprawling buildings, many sports photos focusing on more than one team member, and the majority of animal pictures look best in horizontal mode.

✔ **If your subject has strong vertical lines, use a vertical composition.** The Eiffel Tower, trees, tall buildings, pictures of individuals (whether full length or portrait photos), some kinds of sports shots (basketball comes to mind), and similar compositions all call for a vertical orientation, as you can see in the following figure.

✔ **Use a square composition if vertical and horizontal objects in your picture are equally important and you don't want to emphasize one over the other.** A building that is wide, but that has a tall tower at one end, might look good in a square composition. The important vertical element at one end would keep the image from being too static.

Positioning Your Subjects

A basic skill in composing great images is finding interesting arrangements within the frame for your subject matter. You need to position your subjects, make sure they're facing an appropriate way, and ensure that they are well placed in relation to the horizon and other elements of your image.

Positioning your subject matter

The position of your subject matter within a picture is one of the most important decisions you make. Whether you can move the subject or objects around, change your position, or wait until everything moves to the right spot, you should constantly be aware of how your subject matter is arranged. Follow these steps to compose your pictures effectively:

1. Divide the frame into thirds horizontally and vertically. Above all, you want to avoid having your subject matter centered. By imagining the frame in thirds, you automatically begin thinking of those ideal, off-center positions.

 For more information on selecting the main subject area, *see also* "Choosing a Center of Interest" earlier in this Part.

2. Try to have important objects, particularly your center of interest, at the four intersections. Dividing a composition in this way is called the Rule of Thirds. Objects at any of the intersections will naturally be arranged in a pleasing way, as you can see in the following figure.

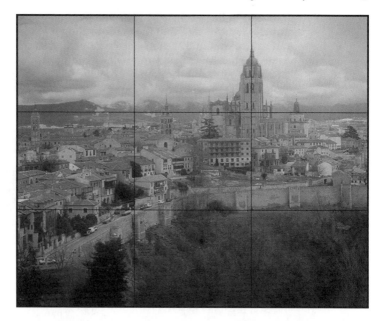

3. Avoid having objects at the edge of a picture unless the part that isn't shown isn't important. If you're taking a picture of a group of people, cropping out part of the building they're standing next to or trimming off half a tree that's not an important part of the composition is okay. But don't cut off heads!

Facing objects into the frame

A photo composition is a whole little world to the viewer. You won't want to destroy the illusion by calling attention to the rest of the universe outside the frame. Here's how to orient people and other objects in a picture:

✔ **If your subjects are people, animals, statues, or anything that you think of as having a front end and back end, make sure that they are looking or facing either the camera, or into the frame, rather than out of it.** If a person seems to be looking out of a picture, rather than somewhere within it, viewers will spend more time wondering what the person is looking at than examining the actual person. The human doesn't actually have to be looking at any object in particular as long as they are looking somewhere within the picture.

✔ **If objects in the frame are moving or pointed in a particular direction, make sure that they are heading into the frame, rather than out of it.** A stationary automobile, a windmill, a palm-tree bent over by a strong wind, anything with a sense of direction to it should be should be facing into the frame for the same reason that a person should be looking into it, as you can see in the following figure.

✔ **Add extra space in front of any fast-moving object (such as a race car) so that the object will have somewhere to go, while still remaining in the frame.** It may seem odd, but if an object is moving having a little more space in the frame in front of it is best so the viewer doesn't get the impression that it's on its way out of view.

Positioning the horizon

The horizon can be a natural part of many outdoors pictures. Even if it's not the most important element (as it would be, say, with a sunset or sunrise photo), the horizon is prominent enough that you should take into account its position when composing your photos.

1. Examine the horizon through the viewfinder. Make sure it is generally parallel with the bottom of the frame. The horizon itself doesn't slope, although it may not be a straight line if mountains, foliage, or other objects delineate its boundaries. In such cases, you still should keep the unseen parts of the horizon in mind when orienting your camera. Otherwise, other elements of your picture will tilt.

2. Point the camera up or down slightly so that the horizon doesn't bisect the picture exactly. Your composition will be more interesting if the horizon is closer to the top or bottom of the frame rather than in the middle. This is another application of the Rule of Thirds. (*See also* "Positioning your subject matter.")

3. If you want to accent the "wide open spaces," choose a low angle that emphasizes the part of the picture above the horizon.

Avoiding unwanted mergers

We've all seen photographs of hapless photographic subjects posed with what looks like a telephone pole growing out of their heads. This mistake is easier to make than you may think, and easier to avoid than you realize. Follow these steps:

1. When composing an image, look behind the subject at the objects in the background. By concentrating, you can see how the background and foreground will appear when merged in your final photograph, as you can see in the following figure.

2. If an unwanted merger seems likely, move the subject to either side, or change your position slightly to eliminate the juxtaposition.

Creating Advanced Compositions

After you have the basics out of the way, progressing to the next level and creating even better compositions is easy. All you need to know is when to apply — or to break — some simple rules. Just remember that one of the key elements of good composition is a bit of surprise. Viewers like to see subjects arranged in interesting ways rather than lined up in a row.

Composing with lines

Lines within your image can help your compositions by directing the eye towards the center of interest. The lines don't have to be explicit; subtle shapes can work just as well. Try these techniques:

- **Look for straight lines in your image and try to use them to lead the eye to the main subject area.** Some lines are obvious: fences, or a seashore leading off into the distance. These kinds of lines are good when you want a dramatic composition.

- **Find diagonal lines to direct the attention to the center of interest.** Diagonal lines are better than straight lines, which are static and not particularly interesting.

- **Use repetitive lines to create an interesting pattern.** Repetitive lines can be multiple lines within a single object, such as the grout lines in a brick wall, or several different parallel or converging objects, such as a road's edges, the centerline of the road, and the fence that runs along the road. Strong repetitive lines can become pleasing compositions in themselves.

- **Curved lines are more graceful than straight lines, and they can lead the viewer gently from one portion of the composition to another.** Curving roads are a good example of arcs and bends that can contribute to a composition, as you can see in the following figure.

✔ **Look for shapes within your composition to add interest. If three objects might form a triangle, the picture will be inherently more interesting than if it were squarish.** Instead of posing groups of people in rows and columns, stack them in interesting arrangements that make shapes the viewer's eye can explore.

Framing an image

Photos are frequently put in frames for a good reason: A border around a picture defines the picture's shape and concentrates our attention on the image within the frame. You can use framing to provide an attractive border around your own pictures by using these tips:

✔ **Look for obvious framing shapes in the foreground that you can place your composition within.** You won't easily miss the most readily apparent frames: doorways, windows, arches, the space between buildings. These have the advantage of being a natural part of the scene and not something you contrived in order to create a frame, as you can see in the following figure.

✔ **Make your own frames by changing position until foreground objects create a border around your image.** Find a curving tree branch and back up until the scenic view you want to capture is wrapped in its leafy embrace. Climb inside something and use an opening as a frame.

✔ **Place your frame in the foreground.** Shapes in the background that delineate your image don't make an effective frame. You want something that appears to be in front of your subject matter, just as a real frame would be.

✔ **Use a frame to create a feeling of depth.** A flat looking image can jump to 3D life when it's placed in a frame. Usually you want to have the frame and your main subject in focus, but you can sometimes use an out-of-focus frame to good effect.

See also "Working with depth of field" in this partchapter for tips on using focus to improve your compositions.

✔ **Use a telephoto lens setting to compress your frame and your subject; use a wide-angle lens setting to add distance between the frame and your main subject.** With a telephoto lens, however, you have to be especially careful to keep the frame in focus.

For more information on using lenses, *see also* Part II.

Balancing an image

If you place every element of interest in a photograph on one side or another, leaving little or nothing to look at on the other side, the picture is imbalanced, like a see-saw with a large child at one end and nothing on the other. The best pictures have an inherent balance that makes them graceful to look at. Use these techniques to balance your image:

✔ **Arrange objects so that anything large on one side is balanced by something of importance on the other side.** This is not the same as having multiple centers of interest. A group of people arrayed on one side need only be balanced out by having a tree or building on the other. The people are still the center of interest; the other objects simply serve to balance the composition.

✔ **To create a symmetrical balance, have the objects on either side of the frame be of roughly similar size or weight.**

✔ **To create a nonsymmetrical balance, have the objects on opposing sides be of different size or weight.**

Optimizing backgrounds

Unless you're taking a picture in the dead of night or on a featureless sand dune or snowfield, you'll have some sort of background to contend with. A background can be a plus or a minus, depending on how you use it in your composition. To make the most of your background:

✔ **Check your background to make sure it is not gaudy, brightly colored, or busy.** The background should not be more interesting than the subject, nor should it be a distraction.

✔ **For portraits, a plain background, such as a seamless backdrop can be effective.** A plain, featureless background can work for portraits as long is it isn't totally bland. Notice how pro photographers who pose subjects against a seamless background still use lights to create an interesting gradient or series of shadows in the background.

✔ **Outdoors, trees, grass, cloud-studded skies, plain walls, and other textured surfaces can make good backgrounds.** Such backgrounds are interesting, without overpowering your subject, as you can see in the following figure.

✔ **Watch for strong lines or shapes in the background that don't lead the eye to your subject.** Straight or curved lines are good for compositions, but not if they distract the viewer from your subject.

✔ **Consider using depth of field to make your background blurry.**

Working with Depth of Field

Depth of field is one of your most powerful compositional tools. You can use it to focus attention on a particular part of your subject, eliminate a distracting background, or create a feeling of intimacy. You'll have the most control over depth of field if your camera has manual focus and exposure controls, but any digital camera can take advantage of this tool.

Estimating depth of field

You don't have to fly blind when using depth of field. You can use some simple techniques for gauging or estimating how much of your subject will be in focus:

- ✔ **If you're using a single-lens reflex camera, you can get a good idea of the amount of depth of field by using your camera's depth of field preview button.** This button stops down the lens to the aperture that will be used to take the picture, providing a good, but not perfect, view of what will be in focus and what will not.

 For more information on single-lens reflex camas, **_see also_** Part II.

- ✔ **Use the LCD picture display on any digital camera to view how much is in focus at the f-stop used to provide the view.** Usually, the preview will be at the camera's widest aperture, which provides the least depth of field. Count on additional objects in focus when you actually take the picture at a smaller f-stop.

- ✔ **Some lenses, particularly those for advanced cameras, have depth of field markings that show how many feet (or meters) on either side of the focus point an object can be and still remain in focus.** For example, if you're taking a picture and focus on an object 10 feet away from the camera, the depth of field lines might show that at f8 everything is in focus from 5 to 20 feet.

- ✔ **Keep in mind that depth of field depends on the size of the lens opening, focal length of the lens, and the distance from your subject.**

- ✔ Calculate approximate depth of field in your head. When you focus on a particular point, that point will be the sharpest. The depth of field for the aperture you use will be applied so that roughly two-thirds of the depth of field is behind the subject and one-third is in front of it. This formula doesn't work when you are very close or very far from your subject, but it's a good rule for many picture-taking situations.

Optimizing depth of field

You aren't stuck with the depth of field you get. As long as you keep in mind the factors that control depth of field, you can apply creative focus to the areas of your picture that you want:

✔ To obtain the most depth of field, use the smallest lens opening you can.

✔ Small apertures (the large numbers, such as f11 or f22) provide more depth of field than large apertures, as you can see in the following figure.

Remember: There are some trade-offs, however. Smaller f-stops may not provide the same sharpness to the object that is at the point of focus as an f-stop in the middle of a lens' range, even though more of your image overall image is in focus. And smaller f-stops mean that you need to use a longer shutter speed, which can contribute to blurry pictures, particularly in dim light.

✔ Use the shortest focal length lens setting that produces the composition you want.

✔ Wide-angle lens settings offer more depth of field at a particular f-stop than telephoto lenses. But keep in mind that by getting very close with a wide-angle setting, you can get apparent distortion of objects that are near the lens.

For more information on lens distortion, ***see also*** Part II.

✔ Back up a little if your composition allows.

The farther you are from your subject, the more depth of field that is provided when you focus on your subject. Of course, you don't want to make your subject too small, which is why controlling depth of field with your lens aperture if at all possible is best.

Using depth of field to emphasize a foreground or background object

Depth of field can emphasize a foreground object, drawing attention to it, as you can see in the following figure. You can also instead emphasize a background object, although you must do so with care because the eye expects the foreground to be in better focus than the background. Just follow these steps:

✔ If your camera has manual focus controls, focus on the fore-ground object. You can even focus a bit in front of the object; because most of the extra depth of field is applied behind the focus point, the object will remain in sharp focus.

✔ If your camera has manual exposure controls, choose the widest aperture you can. Choose the smaller-numbered f-stops, such as f2.8, f2, or f1.4, if your lens has them.

✔ If your camera has an aperture priority setting, choose the widest aperture and let the exposure control set the shutter speed.

✔ Use your camera's close-up setting to get as close as you can, to further reduce the amount of sharpness behind the foreground object.

✔ Use the normal lens setting rather than wide-angle to reduce the amount of depth of field that will be applied to the back-ground.

✔ If your camera has manual focus controls, focus on the back-ground object.

✔ Set the camera's focus to infinity if the background is very far away.

✔ If your camera has manual exposure controls, choose the widest aperture you can.

✔ If your camera has an aperture priority setting, choose the widest aperture.

✔ Use the camera's normal or telephoto setting to reduce the amount of depth of field that will be applied to the foreground.

Using depth of field to eliminate a distracting background

Using depth of field to eliminate a distracting background is basi-cally the same as using focus to emphasize the foreground, but car-ried to the extreme, as you can see in the following figure.

✔ If your camera has manual focus controls, focus as far as you can in front of your subject while still keeping it in focus.

✔ If your camera has manual exposure controls or aperture priority exposure, choose the widest aperture you can.

✔ Use a telephoto lens setting rather than normal or wide angle to put a serious crimp in the amount of depth of field available for the background.

Taking Various Kinds of Photographs

One of the best things about photography is that there are so many different avenues for expression using pictures. You might like to set up painstaking tableaux on tabletops to explore close-up photography of flowers, hobby items, or other objects. Or, you may prefer taking pictures of people as a way of capturing their personalities in an image. Sports photography lets you grab an exciting moment to preserve and share with others. And, after you've returned from a rewarding trip on vacation or business, you'll find your memories of the experience will remain sharper if you have some photos as mementos.

Those four types of photography aren't the only things you can do with a digital camera, of course. But this part will get you started in some of the most popular and interesting kinds of picture-taking.

In this part . . .

Close-up Photography

Getting in close is a good way to produce interesting table-top pictures of flowers, collections (for example, for insurance records or for posting with an online auction service), or close-ups of your pet goldfish or tabby. Digital cameras are particularly good for close-up pictures because you can see your results instantly, and then immediately try different angles or setups.

Small objects all have one thing in common: They don't move. So you can take your time painstakingly setting up the perfect close-up picture. Here are the steps to follow:

- ✔ Use a tripod when taking pictures of inanimate objects. You can arrange your tabletop scene much more precisely when you don't have to worry about the camera moving.

- ✔ Set your camera's lens on its close-up setting. Check your camera's instructions for information on the automatic or manual focusing range when using the close-up setting.

- ✔ If using manual focus, focus very carefully.

- ✔ Use the smallest f-stop you can to maximize depth of field. Of course, you can throw this rule out the window if you plan to use selective focus to isolate part of your subject from the background.

- ✔ If you have a non-through-the-lens optical viewfinder, watch for parallax problems, or use your camera's LCD display.

Flowers often look good when misted with a spray of water just before you take the picture. Don't drench the blossoms! A moist look can be attractive, however, as the following figure shows.

Photographing People

People are the trickiest subjects to photograph because you have to please both the people in the pictures as well as anyone who looks at the photos. The images should look like your subjects — but not too much like them if some flattering lighting or posing can help. To make things more interesting, dozens of different permutations exist of single portraits, group pictures, environmental portraits, business head shots, and other kinds of people pictures.

Capturing a group photo

The key to taking good pictures of a group is to pose them well, and then take lots of pictures and variations. Remember, your digital film is free, or at least, can be reused if you take more photos than you need. That's one of the great advantages of using a digital camera to take photos of people.

1. If you have more than four people in a group, arrange them into two or more roughly equal rows. If your group lines up in a single row, you'll have to back up so far to get them all in that each individual will be tiny. Arranging them in rows with, perhaps, some standing, some seated, and some kneeling in front of them is better. If you have more than three rows, look for risers or steps to arrange your group on.

2. Create an interesting, balanced collection of people. Don't line everyone up in order of height. You might have the taller people in the middle with shorter people on either side of them, but don't make them look like a human staircase. Swap one person for another who's an inch shorter or taller to make your lineup varied.

3. Have your group assume casual, loose poses. They shouldn't be facing the camera dead-on like a firing squad. Have them stand at a slight angle and then turn to look at the camera. A few can have their hands on their neighbor's shoulder, or interacting with their fellows in other ways, as you can see in the following figure.

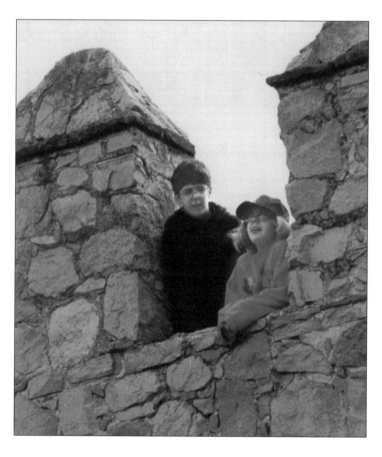

4. Keep the group tight rather than widely spaced. Have everyone get close together. Having each of them turn slightly in the same direction will let you squeeze them together back to front.

5. Shoot from an angle other than head on. Groups look more natural if not photographed from directly in front.

6. Warn everyone just before you snap the photo. Ask them to smile, say "Cheese," or anything that will relax them. Just don't surprise the group. You'll invariably end up with several folks who didn't sit or stand up straight or are otherwise not looking their best.

7. Shoot lots of pictures of a group. The larger the group, the better your chances that someone will have their eyes closed, or will be distracted, sneezing, or looking elsewhere. Consider taking at least one picture for every person in the group; four or five pictures for a group of four, at least eight or ten for groups of up to a dozen. For large groups, you're better off just giving them extra warning and hoping for the best.

Shooting full-length portraits

A full-length portrait is often an excellent way to show more of a subject's personality than you might get from a head-and-shoulders picture. A cheerleader in costume, a football star in full regalia, and a doctor in scrubs are examples of the kinds of full length portraits you may want to take. Here's how to do it:

1. Find an interesting background for your subject.

2. If your camera has a zoom lens, use the "normal" setting. Use a wide-angle setting only if you don't have enough room to step back. Telephoto settings don't work well for most full-length portraits because you have to step back quite a long ways to take in the full figure.

3. Pose the subject in a relaxed and natural way. Try to get your subject to do something. A football player could be hefting a ball; a child could be getting ready to play with a favorite toy.

4. Use creative posing. Have the subject turn slightly rather than face the camera head-on. Ask that he turn enough that his back is almost to the camera, then look back over his shoulder.

5. Shoot several pictures using different poses and facial expressions. Unlike a group picture, with a single portrait, the success of your image depends entirely on how well you capture the personality and look of one single person, as shown in the following figure.

Positioning arms, legs, and head

Your subject doesn't have to be a model to look like one. One key to good people pictures is how you arrange all those body parts! Use these tips:

- ✔ **Arms should be bent slightly, and not straight.**

- ✔ **Show hands edge-on, rather than the flat of the back of the hand or the palms, and have the fingers curved slightly.**

 Avoid showing elbows and bare feet. Some body parts just don't look as good in photos as they do in real life — and many times they look worse!

- ✔ **Have your subjects hold their head up.**

- ✔ **If you have your subject doing something with her hands, pay close attention to how it affects the rest of the pose.** Don't let a fist propping up a chin disfigure the face, for example.

Grabbing a head and shoulders portrait

The head and shoulders picture is what most of us think of as a portrait. Such photos usually focus on the face and expression of the subject, with clothing just an accessory. To take a good head and shoulders shot, just follow these steps:

1. Find an attractive background. The background should be plain or, at least, not busy, and usually shouldn't be a lot more brightly illuminated than your subject.

2. Place a seat for the subject at least three to four feet in front of the background. Stools often work best because they are high enough that the photographer doesn't have to stoop down. In addition, stools are backless so they don't intrude into the picture area, as you can see in the following figure.

3. Seat your subject at an angle to the camera. When seated at a 45-degree angle, the subject can still look directly at the camera. Avoid the "mug shot" look at all times.

4. If your camera has a telephoto lens, use the medium telephoto setting. Doing so lets you back up a little and take a flattering portrait without the apparent distortion a wide angle (or even a normal) lens can cause.

5. If possible, use available light or multiple electronic flashes instead of just your camera's built-in flash unit. Flat, straight-on lighting is seldom flattering.

6. Arrange the lighting so the background and contours of your subject's face are all distinct and separate.

 For more information on lighting portraits, *see also* Part IV.

7. Take several photos, capturing your subject from different angles and using different expressions.

Sports Photography

Capturing exciting pictures at sports events is easy. Something interesting is always happening on the field, court, track, or course. Digital cameras are great for taking sports pictures, because you can view your images seconds after they are taken. You just need to know a few tricks for getting the best photos.

Stopping action

Blurry action pictures can be creative, but most of the time you'll want to freeze the movement so the participants can be seen clearly. Here are the steps to follow to stop them in their tracks.

✔ If your camera can be set to different ISO speed ratings, use its highest setting, typically ISO 400 or more. Using a higher sensor sensitivity will let you use faster shutter speeds without sacrificing sharpness or depth of field.

✔ If your camera has program settings, set to Action. Action program modes automatically calculate the best exposure using a high shutter speed.

✔ If your camera has a Shutter Priority mode, switch to it, and set the shutter speed for the highest available, typically $\frac{1}{500}$ second or faster. When using Shutter Priority mode, your camera will calculate the aperture to use.

✔ If a warning light appears after you set the fastest shutter speed, change to the next fastest setting. Enough light may not be available at your highest shutter speed. Moving down a notch may still let you freeze action in the available light, as you can see in the following figure.

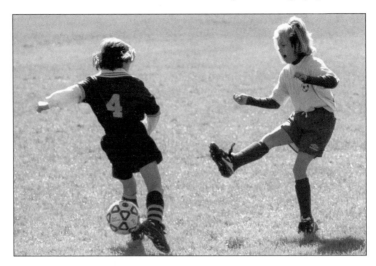

Stopping action with slow shutter speeds

You may end up using a relatively slow shutter speed (⅟₆₀ second or longer) simply because not enough light exists to use a faster speed. Or, you may need the extra depth of field a smaller lens aperture provides. You may even choose to use a slower shutter speed because of the exciting look creative blurring can add to a sports picture. Just follow these steps:

1. If your camera has a Shutter Priority setting, choose the shutter speed you want to use. Your camera will choose an aperture for you when it is set on Shutter Priority. Usually ⅟₆₀ of a second can still freeze some of the action, but don't be afraid to try even slower shutter speeds.

2. If your camera allows you to set an f-stop but not the shutter speed, use a smaller f-stop (the larger numbers, such as f/8, f/11, or f/16). If you mandate a small f-stop, the camera's automatic exposure controls will be forced to use a slower shutter speed.

3. If you want to freeze as much of the action as possible, take the picture when the player, car, or other fast-moving object is headed right toward the camera. Action that occurs in the direction of the camera can be captured at a slower shutter speed than action that crosses in front of the camera, because the apparent motion is less.

4. If you want to freeze action that's crossing in front of the camera's lens, move *(pan)* the camera in the same direction as the subject's motion, and take the picture while you're synchronized. When you follow the moving subject with the camera, you're reducing the amount of relative motion so even a slow shutter speed will freeze the image. However, the background will still be blurry because it is stationary, as shown in the figure that follows.

5. Take the photograph. If you're panning the camera, continue your movement for a short time after you think the picture has been taken. The shutter may still be open, particularly if you're using an extra-long exposure time, such as ¹⁄₁₅ or ⅛ of a second.

Using flash in sports photography

Electronic flash can freeze action even better than a fast shutter speed because the duration of the flash is very brief indeed. Your camera may have a top shutter speed of ¹⁄₂,₀₀₀ of a second or slower. In contrast, an electronic flash may be triggered for ¹⁄₅₀,₀₀₀ of a second or much less. Flash can stop action only in situations where the flash's illumination is much stronger than the available light; you can't use this technique outdoors in bright sunlight, for example. Follow these steps:

1. Switch your camera's flash control to Flash or Autoflash. If your electronic flash has several power settings, use the most powerful setting.

You want enough light to overpower the available light in the room, so the ambient light doesn't provide part of the picture information. That situation can result in *ghosting,* in which the flash stops the action but a blurry secondary image also appears.

2. If the surroundings are bright, use the smallest f-stop (the larger numbers) that your flash allows. A smaller f-stop reduces the chance of ghosting. Your electronic flash may have a recommended f-stop to use at a particular power setting and for a particular distance. Choose the power setting that lets you shoot at the distance you want with a small aperture.

3. Before taking the picture, examine the background to make sure that no shiny surfaces (windows, car windshields, and so forth) are around that might reflect the flash back at you.

4. Take the picture. Be sure to wait enough time after the picture has been taken for the electronic flash to recycle to full strength.

 Automatic flash units may recycle much more quickly at lower power settings or close distances because the full amount of power they contain isn't used for the picture. Only the amount actually used has to be replenished.

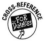

You can find more information about electronic flash in Part IV of this book and in *Digital Photography For Dummies.*

Choosing your spot

An important part of sports photography is choosing your spot. Of course, at professional sports events, you may not have a choice on your position; you buy your ticket and sit or stand where you've been assigned. At amateur sports events, you can often choose the best position. Here are some tips for scouting out a good location to take your photos:

✔ **Make sure that your position won't block the view of other people.** At an amateur football or soccer game, you may be able to stand along the sidelines with the players and coaches, especially if they are located on the other side of the field from the bleachers. If not, try the end zones. At basketball games, the ends of the court (but not directly behind the basket) are good places.

✔ **Choose an appropriate elevation.** High-angle shots work for some sports if you want to show several members of a team who are spread out. Other times, eye-level views are best if you want to focus on one or two players. Low-level, worm's-eye views seldom are effective, especially for sports where the action is very close to the camera. Get down too low for a picture of two basketball players struggling for a rebound and you're likely to get a picture that shows mostly their legs!

✔ **If you have freedom of movement during the event, be prepared to follow the action.** You don't have to wait for the action to come to you. If you can, move around and get a variety of angles and views, as you can see in the following figure.

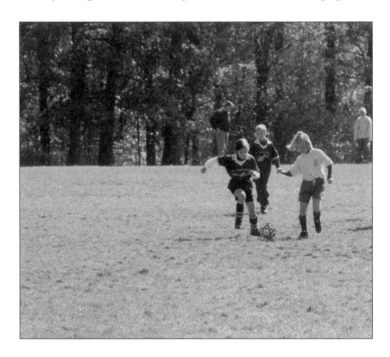

Taking a sports photo

The moment of truth has arrived: time to take your sports photo. Follow these steps to get your prized action shot:

1. Watch the action and try and anticipate what will happen next. Is a runner getting ready to steal a base? Is it third down with 20 yards to go and the quarterback looks ready to throw a pass? Has the goalie strayed too far from the goal? Knowing a little bit about the sport you're photographing can help you anticipate your picture opportunities.

2. Put your camera to your eye long before you're ready to take the picture. Follow the action through the viewfinder so you'll be ready to snap a photo. Some photographers like to keep their other eye open when using a telephoto setting so they can have both an overview of the action as well as the telephoto close-up shot.

3. As the action moves across your field of view, follow it with your camera and snap the picture at the decisive moment. With a little practice, you'll know how to take a picture just before the batter swings, the ball falls into the receiver's hand, or the lead car careens through a hairpin turn, just like in the following figure.

4. Take the picture, and as your camera stores the image in its memory, think of your next photo.

Taking a sports sequence

Some digital cameras have a sequence mode that allows taking a series of pictures in a short time — typically around ten photos in a two-second span. You'll find these images can be a great way to capture any sports event where a lot can happen in a brief period. Here's how to grab a *motor drive* picture series with your digital camera:

1. Set your camera for sequence mode.

2. If necessary, insert a fresh digital film card. You need at least as many shots remaining as the number of pictures in your sequence. Better yet, use a blank card so that you can take several series in a row.

3. Position yourself so you can smoothly follow the action, panning if necessary. Sequences frequently picture a series of movements over a short distance, such as a receiver catching a pass, a base runner sliding home, or a pole vaulter clearing the bar.

4. If you're following moving action, start your camera movement just before you trigger the shutter button.

5. Keep the camera level as the sequence unfolds.

Travel Photography

The saying goes that travel broadens you, and it does. Every trip you take provides the opportunity to exercise your creative bent, document your vacation, or, best of all, preserve precious memories forever. Digital photography is great for travel photography because you can see how your pictures look before you leave a location — possibly forever! The big challenge to taking travel pictures is not a creative one: What do you do with all the pictures you take before you can get back to your computer to download them? Dedicated travel photographers meet this challenge either by traveling with a laptop, or by taking lots and lots of removable storage cards with them.

Taking in scenic views

Every country, state, and province has breath-taking scenic views that stir the soul. Follow these steps to capture this scenic splendor forever.

1. If you have a zoom lens, use a wide-angle setting to capture the broadest possible vista. Wide-angle lenses emphasize the wide, open spaces by including more of the foreground.

2. Use a normal or telephoto setting to grab pictures of distant mountain peaks or other sights you can't approach closely. If the foreground is not what you want to emphasize, avoid a wide-angle setting.

3. Use your camera's highest resolution setting to grab every detail. Higher resolutions will let you crop and enlarge portions of your image later.

4. Attach a skylight filter (which has a very slight pinkish tone) to your lens to reduce the bluish haze that can appear in the distance.

5. Also try polarizing filters to darken the sky (but this technique works only from certain angles) or, if you're shooting black-and-white pictures, use a yellow or red filter to produce dramatic contrast between the sky and clouds, as you can see in the figure that follows.

For more information on filters, **see also** Part II.

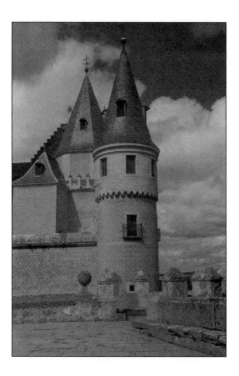

6. To concentrate on the beauty of nature, try to exclude or crop out as many human-made artifacts as possible, such as power lines, cell phone towers, and so forth.

7. Do take a few pictures with humans included (such as members of your party) to add interest and provide a sense of scale. That gigantic mountain will look even larger with a tiny human in the foreground.

Making a panoramic photo

A digital camera and computer makes creating panorama photos a piece of cake. Stitching together multiple pictures to create one very wide-angle view — up to a 360-degree full circle is easy. Just follow these steps:

1. For the most accurate panorama, mount the camera on a tripod with a swivel head that will let you rotate it freely. Technically, the camera should swivel around the center point of the lens to provide perfect panorama perspective. However, if your camera's tripod socket is located off to one side or the other, you'll still be able to get good results.

2. If your camera has a zoom lens, use the widest angle setting. The wider the lens setting, the fewer pictures you'll have to take to cover a particular arc of scenery. For example, a lens that takes in 45 degrees (roughly the same as a normal lens, or a 50mm lens on a 35mm camera), would require eight different pictures to take in a full 360-degree panorama. The equivalent of a 35mm lens would have a 62-degree field of view and require only six shots for a full-circle picture, or just three for a 180-degree view.

3. Use a skylight filter to reduce bluish haze in the distance.

 For more information on filters, *see also* Part II.

4. Place a lens hood on your lens. As you swivel the camera, that the sun will be prominent for one or more of your photos is almost guaranteed.

5. Take your first shot.

6. Notice landmarks at one side of the frame, then swivel the tripod so that same landmark is at the other side of the new frame.

 Use a tree, mountain peak, or some other fixed object. Overlapping a little is okay (preferable, actually) so you can stitch the pictures together.

7. Take the next shot.

8. Repeat Steps 6 and 7 until you've photographed the full panorama that you want.

9. Back at your computer, load all the images into your image editor and combine them. You may have to adjust the brightness and contrast so the pictures match, as shown in the figure that follows.

 You'll find more information on adjusting brightness and contrast in Part VII.

Editing Images

If every picture tells a story, most of your digital images could benefit from some judicious editing. Whether you use the most popular image-editing program — Adobe Photoshop — or another software package, such as Adobe PhotoDeluxe or Corel Photo-Paint, you can find desktop tools that can make your images look their best.

You can accomplish most techniques for editing images with any image editor, but Photoshop is the most widely used, and if you master its tools you'll never run short of ideas or the capabilities needed to implement them. With your image-editing software, you can correct colors, resize or crop pictures, add or subtract elements, and create artistic effects.

 If you want more detail on working image-editing magic, pick up a copy of *Photoshop For Dummies*.

In this part . . .

Image Hues and Tones

Changing the colors and tones (shades) used to represent your image can make a dramatic difference, whether you're just trying to make the photo look good, or wanting to jazz up a snapshot with a few modifications. You'll want to change hues to correct color and adjust tones to make images brighter or darker. Most image editors provide two ways of setting these controls: directly manipulating the values for brightness and contrast or adjusting the relative levels of each.

Correcting brightness/contrast values

All image-editing programs have easy slider controls built-in, like the ones shown in the figure that follows, that let you make rudimentary changes in brightness and contrast. Just follow these steps:

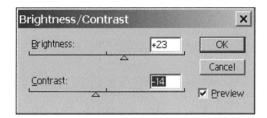

1. Access your image editor's brightness/contrast controls. The typical dialog box has a pair of sliders. One adjusts brightness from very light to very dark, and everything in between. The other modifies contrast from very "flat" to very contrasty.

2. Move the brightness slider first until the image begins to look better. *Brightness* is the overall intensity of your image. An overexposed image may be too light, or an underexposed image may be too dark.

 Contrast is the number of light and dark tones in a photo. If a picture is mostly black and white with few grays, it is too contrasty; if it has a lot of gray with not much white or black, it is flat or uncontrasty, as you can see in the following figure.

3. If your picture isn't perfect, readjust both sliders until you get the settings you want.

4. Click OK to apply your change, or Cancel to leave the image unchanged.

Correcting brightness/contrast levels

Many times the standard brightness/contrast controls won't fine-tune your image as much as you'd like. Image editors have more sophisticated controls such as Curves and Levels. Photoshop's Levels control is the easier to use than Curves, because it simply involves moving a few sliders, rather than trying to achieve corrections by twisting curves on a graph. Just follow these steps:

1. In Photoshop, press Ctrl+L. In the dialog box that appears, you can see the amount of dark and light tones in your image displayed as a sort of "mountain range," with the peaks representing dark tones on the left, and those representing light tones on the right.

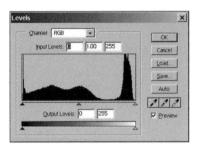

2. Move the black triangle at the left side of the display to the right until it reaches the "foothills" on the left side of the mountain range.

3. Move the white triangle at the right side of the display to the left until it reaches the foothills on the right side of the mountain range.

4. Move the gray triangle in the middle of the display to the left or right, until the image of your photo looks its best.

5. Click OK to apply your change, or Cancel to leave the image unchanged.

Correcting a color cast

Even well-exposed images can have an unwanted color cast. For example, pictures taken at dusk may be too red. Those exposed on the ski slopes may be too blue. Follow these steps to fix those colors:

1. Access your image editor's Color Correction dialog box. (Photoshop users can press Ctrl+B.)

2. Move one of the color correction sliders toward a color to add more of that color, or away from that color to reduce the amount of that color. For example, if your image is too red, you can move the slider away from the red end, toward its complementary color, cyan.

3. If necessary, move a second slider to reduce any remaining color cast.

 Remember: Move only two sliders, and always move them in the same direction. Moving two sliders in different directions or moving all three cancels out some of your changes.

 Experiment to pin down the exact color cast you have; an image that appears to be too green may actually be too blue-green (cyan); one that appears to be too reddish may actually be too magenta (reddish-purple).

4. Your image editor may have controls that let you adjust the color for shadows, middle tones (the shades between the lightest and darkest), and highlights (the lightest shades) separately. Use them to fine-tune your image.

5. Click OK to apply your change, or Cancel to leave the image unchanged.

You can find more information about correcting brightness, contrast, and colors in *Digital Photography For Dummies*.

Correcting color with variations

Photoshop has a hassle-free way of correcting colors visually called Variations. You can view different versions of your image side by side and choose the one that looks best.

1. Access Photoshop's Variations dialog box by choosing Image⇨Adjust⇨Variations.

2. In the Variations dialog box, shown in the following figure, choose whether you want to adjust shadows, midtones, highlights, or *saturation* (the richness of the color).

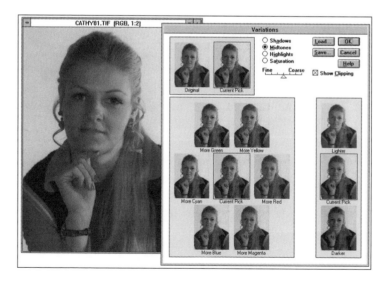

3. View the alternatives shown and click the one that improves the look of your image.

You can choose from among adding red, blue, green, yellow, magenta, or cyan, plus change the lightness and darkness and saturation.

 4. Click OK to apply your change or Cancel to leave the image
 unchanged.

Changing to grayscale

You may want to change a color image to grayscale, perhaps to
view how it will look when printed or photocopied, or simply
because you like the retro look of a grayscale (black-and-white)
photograph. Follow these steps:

 1. Access your image editor's dialog box for converting to
 grayscale. The feature may be called one of several different
 things: In Photoshop choose Image⇨Mode⇨Grayscale. Other
 editors may use Desaturate or Indexed Color (which converts
 to a 256-hue image, either color or grayscale).

 2. Specify any options your editor offers

 3. Click OK to make the change, or Cancel to abort the operation.

Colorizing a grayscale image

If you take a picture using your camera's black-and-white mode and
later want to add colors, you can simulate a full-color image by
using a colorizing or toning process that gives you a look similar to,
say, a sepia-toned photo. Just follow these steps:

 1. Select your image editor's colorizing mode. In Photoshop,
 choose Image⇨Adjust⇨Hue/Saturation and click the
 Colorize box.

 2. Adjust the color or hue slider until the grayscale image
 assumes the color you want.

 3. Move the saturation slider to adjust the richness of the color.

 4. Click OK when finished to apply your change or Cancel to
 leave the image unchanged.

Making a negative image

A negative image can add a spooky or artistic effect. When you
make a negative of a grayscale image, the picture takes on the look
of an Xray, as shown in the following figure. If you reverse a color
image, the colors are reversed, too. (That is, blue becomes yellow;
green becomes magenta; cyan becomes red, and vice versa) To
make a negative image:

1. Choose your image editor's Invert/Inverse/Reverse or Negative
command. In Photoshop, choose Image⇨Adjust⇨Invert.

2. If your image editor uses a dialog box to create a negative
image, click OK to apply the change, or Cancel to leave the
image unchanged.

Making a black-and-white image

A black-and-white high contrast image has a stark, arty look that
can be effective. Such pictures contain only black and white, with
no gray tones at all. You can go with the black/white "photocopied"
look, or replace your grays with patterns called *dithers,* as you can
see in the following figure.

1. Choose your image editor's black-and-white or high-contrast image mode. With Photoshop, choose Image⇨Mode⇨Bitmap.

 If you're starting with a color image, you may have to convert it to grayscale before the black and white/bitmap option is available. With some image editors, you can convert an image to black and white by adjusting the brightness and contrast sliders.

2. Choose how to generate the black-and-white image.

 Usually the program offers the choice between several patterns of dots and a basic threshold option in which all tones lighter than a middle gray are rendered as white and all tones darker than a middle gray are rendered as black.

3. Click OK to apply the change, or Cancel to leave the image as it was.

Creating a poster-like image

Poster effects are eye-catching and lend themselves to printed material. Most image editors have an option for converting full-color or grayscale images to poster-like images, like you see in circus graphics, with only a limited number of tones, like the photo in the following figure.

1. Choose your image editor's Posterization command.

2. Select the number of tones for the image.

 A small number of tones, from four to eight, produces the strongest poster effect. A larger number, such as 16 to 24, provides a less obvious effect, as you can see in the following figure.

3. Click OK to apply the change, or Cancel to leave the image as it was.

Image Size, Cropping, and Orientation

Images may not be the size you want, or could use some cropping to eliminate subject matter you really don't need. You also can rotate an image to change its orientation. For example, you might want to eliminate Uncle Harry, your least favorite relative, from a wedding photo in which he wasn't an official member of the wedding party but managed to insinuate himself into the picture anyway. (Good thing he's standing on the end!) You can rotate a picture to change it from a vertical to a horizontal orientation.

Cropping an image

Trimming an image can create a stronger, more focused photograph. You can eliminate extraneous material using your image editor's cropping feature. Many image editors have two different ways to crop: cropping from a selection (where you select a rectangular portion of the image, and then cut out everything else), and cropping using a special crop tool.

To crop from a selection:

1. Use the rectangular selection tool (which usually looks like a dotted line rectangle) to mark off the image you want to preserve.

2. Choose the crop command (in Photoshop, choose Image⇨Crop).

To crop using the Crop tool:

1. Select the Crop tool.

2. Use the tool to mark the section of the image you want.

 With Photoshop's Crop tool, you can resize the cropped area at any time, or rotate it.

3. Activate the crop action. If you're using Photoshop's Crop tool, press Enter when you're ready to clip your image. (Remember that after you save a cropped image, the portion you've cropped out is gone forever, unless you've saved a backup copy.)

Making an image larger or smaller

You may want to make an image larger or smaller, either so it will print at a different size, or to make it similar in size to another picture you want to combine it with.

1. Choose your image editor's Image Size or Resample command. With Photoshop, choose Image⇨Image Size.

2. In the command's dialog box, like the one shown in the following figure, view the current size in pixels, inches, or some other measurement, such as millimeters, picas, or points.

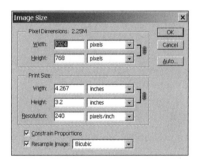

3. Enter the new size you want in pixels, inches, or another measurement; or specify a percentage increase or decrease.

You can enlarge an image measuring 640 x 480 to 1024 x 768, or reduce it to 320 x 240. Or, you may want to enlarge it to 150% of its present size, or reduce it to 75% of its present size.

 For more information on resolution and resizing images, see *Digital Photography For Dummies.*

4. If you want to stretch the image more in one direction than another, (say, to make someone seem taller and thinner!) uncheck the Constrain Proportions or Keep Aspect Ratio boxes in the dialog box. Then, type in separate values for the horizontal and vertical dimensions.

5. Click OK to apply your change, or Cancel to revert to the original image.

Making an image print larger

Many editors let you specify a printing size that's different from what you get at the current image's size. That is, a 600 x 600-pixel image created with a resolution of 100 pixels per inch prints by default at 6 x 6 inches. You could change the printing size to 8 x 8 inches if you like, if you wanted to fill up a sheet of paper more completely. To print an image larger:

1. Choose your editor's Image Size or Print Size command. With Photoshop, choose Image➪Image Size.

2. Enter the Print Size dimensions in the dialog box, using inches, which will usually be the default, unless you live in Europe (in which case the default will be centimeters) or have selected another unit of measurement.)

3. If you want to stretch the image more in one direction than another, uncheck the Constrain Proportions or Keep Aspect Ratio boxes in the dialog box. Then, type in separate values for the horizontal and vertical dimensions.

4. Click OK to apply your change, or Cancel to revert to the original values.

Rotating an image

You can rotate an image to change its orientation (for example, to flip it on its side, making a horizontal picture a vertical one, or vice versa) or to straighten a slightly crooked photo.

1. Choose your editor's rotation command. In Photoshop, choose Image⇨Rotate Canvas.

 Although the contents of an image can take any angle of rotation, the entire image must always be square or rectangular with its sides parallel to the top and sides of the screen. So, if you rotate an image to other than a 90% angle, the image editor will create rectangular boundaries that are parallel, as shown in the figure that follows.

2. If you want a standard amount of rotation (in 90 degree increments) choose the amount of rotation you want from the menu or dialog box. Usually, you're offered choices like 90 Degrees Clockwise or 90 Degrees Counterclockwise (or, with some images, 90 Degrees Right or 90 Degrees Left), as well as 180 Degrees or some other amount in whole 90 degree increments.

3. If you want to rotate the image an arbitrary amount (that is, an amount you specify), choose Arbitrary or its equivalent from the menu or dialog box and type in the amount of rotation you'd like.

4. The rotation will either be applied automatically as you rotate the image, or, with some image editors, you might need to click the OK button to rotate the image.

Flipping an image horizontally or vertically

You can also flip an image horizontally (right to left) or vertically (up and down) to provide a mirror image, say to have someone facing left instead of right, or to create a reflection, as in water, as you can see in the figure that follows.

1. Choose your image editor's rotation or flip image command. In Photoshop, choose Image⇨Rotate Canvas.

2. Select Flip Vertical or Flip Horizontal from the menu or dialog box (if your image editor uses one).

Rotating, flipping, or resizing only part of an image

Sometimes you'll want to rotate, flip, or resize only part of an image, leaving the rest of the image untouched. Just follow these steps:

1. Use your image editor's selection tools to choose the part of the image to modify.

 When you transform only part of an image, you can work with oval, circular, or odd-shaped selections (and not just rectangular shapes). Use any of the selection tools at your disposal.

2. Choose your image editor's command to rotate, flip, or resize a selection. With Photoshop, choose Edit⇨Transform and specify Scale, Rotate, Rotate 90° CW, 90° CCW, Flip Horizontal, Flip Vertical, and so forth.

When scaling or rotating by an arbitrary amount, use the mouse to drag the selection's handles to achieve the modification you want.

3. The transformation happens automatically; or if it doesn't, click the OK button to apply the change.

Creating a perspective effect

You can create a perspective effect to give a 3D look to a flat, 2D image, say, to create a Web page button out of a flat photograph. Just follow these steps:

1. With your image editor's selection tools, select the portion of the image you want to transform.

2. Choose the perspective command. In Photoshop, choose Edit⇨Transform⇨Perspective.

3. Drag the selection boundaries that appear with the mouse until the effect you want is made, as shown in the following figure.

4. Click OK or press Enter (as required by your image editor) to apply the change.

Manipulating Images

Some modifications can greatly enhance the appearance of an image. You can make the image sharper, remove dust and scratches, or darken or lighten portions.

Selecting the part of a photo to work on

You can apply most image modifications to part of an image. Use your editor's selection tools to specify which part you want to change. Choose from among these options:

- ✔ **To select rectangular or square portions of the image:** Use the Rectangular Selection tool or Marquee. Drag with the mouse, holding down the shift key if you want the selection to be a perfect square.

- ✔ **To choose an oval or circular portion of the image:** Use the Oval Selection tool or Marquee. Drag with the mouse, and hold down the Shift key if you want the selection to be a perfect circle.

- ✔ **To draw a freehand selection line around part of an image:** Use the Lasso tool. Click once and hold down the mouse button while drawing the selection boundaries.

- ✔ **To draw a selection using line segments:** Use the Polygonal Lasso tool. Click once at the beginning of the selection, then click again at another point to draw a selection line segment to that point. Repeat until you've made your entire selection.

- ✔ **To draw a selection that "hugs" the borders of an object:** Use the Magnetic Lasso tool.

- ✔ **To "paint" a selection using any painting or erasing tool:** Use the Quick Mask tool.

More information on selecting parts of images and applying retouching effects can be found in *Digital Photography For Dummies.*

Sharpening an entire photo

You can improve the look of a slightly blurry photo by applying the right amount of sharpening. To do so:

1. Select the entire image (usually you can do so by pressing Ctrl+A).

2. Choose your image editor's Sharpen command. In Photoshop, you choose Filter⇨Sharpen.

You can select from among several types of sharpening, with options like

- **Sharpen:** Makes the image a little sharper.

- **Sharpen More:** Makes the image somewhat more sharp.

- **Sharpen Edges:** Just sharpens the edges of objects in your image.

- **Unsharp Mask:** Lets you "dial in" the specific amount of sharpness you want based on a preview image, as you can see in the following figure.

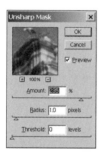

3. If you're using a dialog box, click OK to apply the sharpening, or click Cancel to revert to the original image.

Sharpening part of a photo

Sometimes you may want to sharpen only a portion of a picture:

1. Select the portion of the image you want to sharpen, using the selection tools as described in the preceding section.

2. Use either your image editor's Sharpen tool to "paint" the area you want to sharpen, or select the Sharpen command from the menu.

3. If you're using a dialog box, click OK to apply the sharpening, or click Cancel to revert to the original image.

Eliminating dust and scratches

Most images have a special Dust & Scratches command to remove dust spots, scratches, and other tiny defects quickly:

1. Select the entire image, or only that portion that you want to process for dust and scratches.

2. Choose your image editor's Dust & Scratches command. In Photoshop, you choose Filter⇨Noise⇨Dust & Scratches.

3. Use the sliders in the dialog box, if provided, to adjust the preview image so the dust and scratches are obscured, as you can see in the following figure.

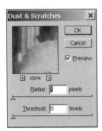

4. Click OK to apply the change, or Cancel to revert to the original image.

If your image editor does not have a Dust & Scratches command, you can minimize the appearance of these artifacts by applying a slight amount of blurring, as described next.

Softening all or part of an image

Judicious use of blurring can reduce dust and scratch marks, obscure graininess, and minimize other defects.

1. Select the entire image, or only that portion that you want to blur.

2. Choose your image editor's Blur command. In Photoshop, you choose Filter⇨Blur.

Usually, a dialog offering several blurring options appears. Some of the options include:

- **Blur:** Makes the image slightly blurry.

- **Blur More:** Makes the image much more blurry.

- **Gaussian Blur:** Lets you dial in the exact amount of blurring you want.

- **Motion blur:** Gives a streaky effect in one direction as if caused by fast movement.

- **Radial blur:** Makes the selection look as if it were rotating.

- **Zoom blur:** Looks as if the image suddenly grows or shrinks, as with a zoom lens.

3. When satisfied with the preview, click OK to apply the change, or Cancel to revert to the original image.

Darkening parts of an image

You may want to darken only part of the image. Image editors usually offer several ways to do so. Your options may include:

✓ Selecting the portion of the image you want to darken, then applying the Brightness command.

✓ "Painting" the area darker using the Burn or Darken tool of your image editor.

Lightening parts of an image

You may want to lighten only part of the image. Image editors usually offer several options to perform this kind of modification. They may include:

✓ Selecting the portion of the image you want to lighten, then applying the Brightness command.

✓ "Painting" the area lighter using the Dodge or Lighten tool of your image editor, as you can see in the following figure.

Retouching and Combining Images

Other kinds of modifications may improve an image, or actually change its appearance dramatically to create a whole new image or effect. Image editors let you retouch images, remove elements, add new objects, or label elements with text.

Eliminating red-eye

"Red-eye" is caused when light from an electronic flash bounces off the retina of the eye, producing orange-colored pupils in a photograph, like the one in the figure that follows. The effect is more obvious when the picture is taken in a darkened room and the pupils are wider and more prominent. Image editors can easily remove the effect. To remove red-eye:

For more information on red-eye, *see* Part IV.

1. If your image editor has a special "red-eye" command, select it and mark where the eyes are in your image.

2. If your image editor does not have a "red-eye" command, use your selection tools to select the orange area.

3. Use your Brighten/Contrast tools to darken the area and reduce the contrast.

4. Use your color correction tools to change the red/orange back to a more natural color.

 Presto! You've eliminated red-eye!

Removing unwanted elements

You can easily remove everything from a telephone pole growing out of a subject's head, to the smiling face of a relative who has fallen out of favor from an image using an image editor's Rubber Stamp or Clone tool. Just follow these steps:

1. Choose your image editor's Rubber Stamp or Clone tool.

2. Select a portion of the image that you'd like to copy to place over the part you want removed. In Photoshop, you hold down the Alt key while clicking with the mouse in that portion.

 You may want to choose an area of the background that's near the area to be removed, or a generic object (such as a bush) that you can paint over the unwanted element.

3. Choose a brush size that will let you paint over the object in strokes.

4. Paint the replacement area over the unwanted element, as shown in the figure that follows.

Adding new objects to pictures

Image editors offer several different ways of adding new objects to pictures. Here are some of your options:

- ✔ Select the object you want to insert and copy it to the clipboard. Then paste it into its new location. You may need to erase portions of the pasted object to help it blend into the image.

- ✔ Use the Rubber Stamp or Clone tool to paint the new object into the picture.

- ✔ Copy an area of the image containing the object you want to insert. Then select the portion of the new image where the object will go using your selection tools. Use the Paste Into command to place the new object into the area you've selected.

Adding text to a photo

Text can be used to add call-outs, captions, or labels to your images. All image editors have a text tool that lets you add from small amounts of text up to entire paragraphs to your image.

1. Choose your image editor's text tool.

2. Choose the color you want the text to appear in as the current foreground color.

3. Click the position where you want the text to appear.

4. When the text dialog box pops up, choose the font and size of the text you want to add.

5. Choose any special formatting, such as bold or italic.

6. Select an orientation for the text, either vertical or horizontal, if your image editor offers that option.

7. Choose alignment for the text, such as flush left, centered, or flush right.

8. Type the text, as shown in the figure that follows.

9. Click OK when finished, or Cancel to revert to the original image.

Special Effects

Adding artistic painting effects

You can turn a snapshot portrait into a portrait painting using the painterly effects built right into image editors. Just follow these steps:

1. Select the entire image or the portion you want to add brush strokes to.

2. Choose one of the stroke-like effects from your image editor's filters or special effects menu.

 In Photoshop, you can find some of the best filters to experiment with by choosing Filters and then either Artistic, Brush Strokes, or Sketch. You can get effects like those shown in the following figure.

3. Play with the values available in the dialog boxes to vary brush stroke length, intensity, and other parameters.

4. Preview the effect in your image or the preview window provided.

5. Click OK to apply the effect.

6. If the effect is too strong, fade it slightly. In Photoshop, you choose Filter⇨Fade.

Distortion effects

Distortion effects twist and turn your image to give it a warped look that can be interesting and artistic. Most images have half dozen to a dozen different distortion filters and special effects, like those shown in the following figure. Follow these steps:

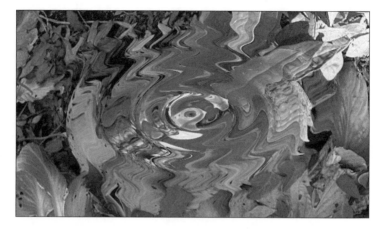

1. Select the entire image or the portion you want to distort.

2. Choose a distortion effect from your image editor's Filter or Special Effects menus.

 Spherize wraps the selection around a sphere; twirl filters spin the selection around; wave and zigzag effects produce ripples in your selection.

3. From the filter's dialog box, choose the parameters you want to fine-tune the image. You may be able to select from intensity of the effect, number of ripples, and other options.

4. Click OK to apply the effect, or Cancel to revert to the original image.

Enhancing cloud effects

Are the clouds in your pictures not dramatic enough? Add your own; it's easy, as you can see in the figure that follows. Follow these steps:

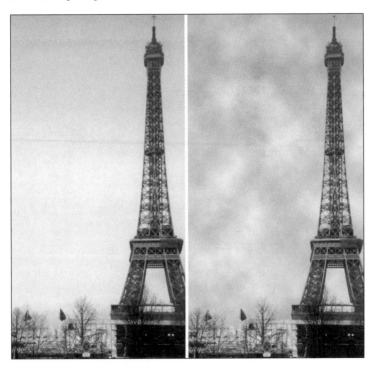

1. Use your selection tools to select the area of the sky (or another portion of the image) in which you'd like to apply a cloud effect.

2. Choose a pair of colors to use for the clouds and the sky. Usually, choosing a sky-blue and white pair makes sense, but you can have light-blue clouds on a green background if you like.

3. Select the Clouds filter available in your image editor. In Photoshop, choose Filter➪Render➪Clouds.

4. Click OK to apply the cloud effect, or Cancel to revert to the original image.

Making pictures sparkle

You may add star-like sparkles, blazing suns (in multiples, if you want a sci-fi look), or some other bit of flare to your image. Just follow these steps:

1. If you want to confine the flare to a particular part of the image, select that portion.

2. Choose the lens flare or star filter/special effect. In Photoshop, you choose Filter⇨Render⇨Lens Flare.

3. Choose the kind of flare you want. Image editors may let you choose from star effects, or various types of flares typical of zoom lenses, wide angles, and other optics.

4. Use the cursor in the preview area of the dialog box to move the center of the flare to the position you want.

5. Click OK to apply the effect, or Cancel to revert to the original image.

Adding texture

Texture can add some interest to an object in one of your photos, or even transform it into something entirely new, as you can see in the following figure. Image editors all have facilities for adding some texture to photos. Just follow these steps:

1. Use your selection tools to choose the portion of the image you want to texturize.

2. Choose your image editor's texturizer filter, special effect, or dialog box.

3. Select the kind of texture you want to apply. Image editors typi-
 cally let you choose from sandstone, canvas, glass, brick, and
 other textures.

4. Use the dialog box's options to set the text you want.

 You can change these items:

 • **"Depth" of the texture:** The amount of relief, or distance the
 texture appears to rise above the surface of the photo

 • **Relative size of the texture:** Its scale, compared to the rest
 of the image

 • **Additional parameters:** Such as the location of the light
 source that casts the shadows that make the texture visible

5. Click OK to apply the texture, or Cancel to return to your origi-
 nal image.

Getting Creative with Your Photos

You've mastered taking digital pictures. What do you do with those pictures? Grabbing photos for their own sake is a lot of fun, perhaps so you can display them on your computer or print out a few copies to share with friends, relatives, and colleagues. But the obvious applications for digital photos are just a starting point. This part presents some ideas for ways you can put your images to work in a variety of interesting ways.

In this part . . .

Inserting Photos in Publications

Your digital photos don't have to exist only within your computer or as simple hard copies that you print out. Finding applications for your pictures in all kinds of publications is easy. Here are some suggestions.

Creating an organizational chart or family tree

Organizational charts and family trees have something in common: a hierarchical structure, with the head honcho (or the individual whose family is being profiled) listed at the top of the heap and all the underlings (or ancestors) distributed beneath, or, perhaps to the side. Here's how to create your own photo org chart or family tree:

1. Make a list of all the individuals to include and photograph as many of these folks as you can. In the case of long-gone ancestors, use existing photos by scanning them in or having a friend or colleague scan them for you.

For more information on scanning, see *"The Official Hewlett-Packard Scanner Handbook,"* published by Wiley Publishing, Inc.

2. For the best results, photograph each person under similar conditions. Use similar lighting, head sizes, and backgrounds. For an interesting touch, use different color backgrounds for each corporate level or generation to help tie together those on the same level.

3. Crop the pictures so they are all the same size.

Using slightly larger sizes for upper management and smaller sizes for the foot soldiers is okay. At least upper management will be pleased.

4. Create or open the org chart or family tree you want to illustrate.

5. Insert the photos.

Virtually all software you can use to create these charts, from business graphics programs like Microsoft Visio to family tree applications, let you insert pictures, as you can see in the following figure.

6. Print out a copy of the chart with photos included, or e-mail it to family members, or even post it on your Web site.

Creating newsletters

Digital photos can make a great addition to company newsletters, brochures, and other publications, as well as your annual holiday letter to all your relatives. Here are some guidelines for getting the best results:

1. If the publication will be printed professionally or reproduced by a sophisticated photocopier, use the highest resolution available with your camera. You want the pictures to be at least as sharp as those taken with conventional film cameras.

 For more information on getting the sharpest pictures, *see also* Part II.

2. If your camera allows saving in uncompressed format, raw format, or as a TIFF file, then do so.

 This may mean you can fit only one or two pictures on a digital "film" card, but the superior results will be worth it. For more information on digital film cards, *see also* Part III.

3. Retouch the picture in your image editor.

 For more information on retouching pictures, *see also* Part VII.

4. Save as a TIFF file.

5. Place the image in your newsletter or brochure using your desktop publishing program, or supply the image to your printer.

 The following figure shows an example of the kind of results you might get.

Kitchen Table, Inc News

Loading Dock Chief Bowls Perfect Game

Scott N. Hollerith, loading dock foreman, helped lead the Kitchen Table, Inc. bowling team to the all-league championship last Friday by bowling a perfect 300 game and 857 series at Lois Lanes. It was Hollerith's fourth 300 game in the last four months as he boosted his average to 240 this season.

The KTI team, the High Roallers, took first place among all teams in the Tri-County area.

Creating birth announcements

Babies don't really look all alike. Yours is special. It's the other babies who all look alike. To prove it, you'll want to include a photo of your new kid in the birth announcement. The announcement can be a piece you print yourself or, in the computer age, sent as an e-mail. Here are the steps:

1. Take a photo of the baby. Use available light if you're afraid the flash may hurt the infant's eyes. Newborns don't smile much, but they look very cute while asleep with their little hands clenched. For bonus points, have the baby wearing clothing given by the grandparents, preferably something from each set (of grandparents, not clothes).

2. Crop the photo in your image editor to concentrate on the baby's face.

For more information on cropping and other image editing steps, *see also* Part VII.

3. If necessary, adjust the color to remove excess reddish or other tones.

4. Use a greeting card program or desktop publishing application like PrintShop to create a good-looking card. These programs let you assemble your own pictures into cards based on templates supplied with the software, or designs you build yourself from scratch.

5. Print the announcement on a photo-quality ink-jet printer to do justice to the handsome infant.

Creating newspaper-ready photos

Many local newspapers accept photos for publication in digital form. If your club has an activity and can't convince a photographer from the paper to show up, or if you just returned from vacation and want all your neighbors to be envious of where you've been, or if you have that once-in-a-lifetime news photo that belongs on the front page, follow these steps to get results like those shown in the following figure:

RAVENNA

Students enjoy trip to Spain

Immaculate Conception group visits country for 11 days

Four students from the Spanish Club at Immaculate Conception School in Ravenna recently spent 11 days in Spain, learning about the country and its culture.

Fifth-graders Allison Kluge and Teryn Busch and seventh-graders Jon Busch and Timothy Pagliari explored the ruins of an ancient Roman amphitheater and wandered La Mancha with three parent chaperones, Sarah Kluge and Cathy and David Busch.

Along the way, the group visited the walled city of Avila, the birthplace of St. Theresa and spent a night in the 14th Century monastery that is home to Our Lady of Guadalupe.

Led by veteran Spanish traveler Cathy Busch, the club's adviser, the group used rental cars to explore parts of Spain seldom visited by package tours.

They visited remote villages and once found lodging in the rambling palace of the Count of Oropesa.

The trip's leisurely pace gave the students and their chaperones time to participate in everyday Spanish activities, such as the evening paseo (stroll) through the town square,

shopping for food and snacks in town markets and enjoying meals of authentic regional cuisine at the traditional Spanish dinner hour of 9 p.m.

The group also found time to visit traditional tourist cities,

such as Toledo and Segovia, spending a few nights at each city and exploring them thoroughly.

The trip finished with a two-day stay in Madrid, where club members visited the Plaza

Mayor, picked up bargains at the El Rastro flea market and viewed Picasso's masterpiece, "Guernica."

The students also practiced their language skills with the native Spaniards.

Four students from Immaculate Conception School in Ravenna recently visited Spain with three parent chaperones. Posing in front of the Ayuntamiento, a 16th century palace in Toledo, Spain, are seated, from left, Allison Kluge, Teryn Busch and Jon Busch. Standing is Tim Pagliari.

1. Take the picture using the maximum resolution of your camera.

For information on maximizing resolution, ***see also*** Part II.

2. Save the picture onto your digital "film" card using the least amount of compression available.

For information on storage, ***see also*** Part III.

3. In your image editor, correct for bad color or exposure if you want, but don't make any extraordinary changes through retouching.

For information on correcting color or exposure, ***see also*** Part VII.

You may think it doesn't matter much for an amateur photograph, but newspapers stake their integrity on presenting accurate, unmanipulated images. If they found that amateurs were making significant changes to digital pictures they submitted, the newspapers might become more reluctant to accept them. Don't spoil everything for everyone else by cooking up a picture of you standing next to Elvis. (Unless you're sending your photo to a well-known tabloid!)

4. If the picture is 1.4MB or smaller, save it on a floppy disk.

If the picture is large, you can save it on a Zip disk or other media. Find out what the newspaper accepts. Papers prefer the original electronic file to a hard copy, which may not be of good enough quality for reproduction. The newspaper would just scan it back to electronic form anyway.

5. Submit the picture to the newspaper along with a caption that lists the names and other information about everyone in the photo. Include a phone number where you can be reached if the newspaper staff has additional questions.

Slide Show Presentations

Digital pictures are perfect for computerized presentations. They have the right resolution, can be produced quickly, and can spice up the most boring presentation. This section has suggestions for two ways to use them.

Even if you swear you're a non-visual learner, it's impossible not to be drawn to pictures.

If you're over 40, you probably remember dreading being called over to your neighbor's house so they could set up a slide projector and show you a million vacation slides. If you're under 40, consider yourself lucky. Today, though, no one is safe from the vacation slide show. You can create one using presentation software like PowerPoint. Just be merciful and make the presentation *interesting.*

In terms of business, slide shows have to communicate a message: Buy our product; hire our firm; here are some cool things we did last year; this is how we operate. What better way to get these points across than with digital images? Because you can create a digital image quickly, you can easily keep your presentation updated with your latest products, personnel, or other information. Just follow these steps:

1. Collect all the digital pictures you want to include in the presentation and choose only the best ones.

2. Arrange the pictures around one or more themes.

You could sort them by your itinerary if you like, but most viewers won't particularly care what order in which you saw the sights. Instead, consider arranging them by city or region and then presenting them roughly in the order of what is most interesting. That way, you won't have to worry about having to stop the show when the audience rebels before reaching the good stuff. You can also arrange a show by type of sight, such as cathedrals, museums, or particularly impressive gift shops.

3. Choose an interesting presentation format from among those offered by your software's wizards or templates.

However, for business presentations, creating a custom-designed format to avoid the "canned" look is often worth your while.

4. Insert the photos in the presentation, as shown in the following figure.

Generally, you'll want one photo per page for personal use, but if you have two small pictures that fit together, don't be afraid to include them on a single page.

In business presentations, not every page has to include a picture. In fact, you may want to reserve them for particular places in the show to spice up the presentation or to call attention to a particular product, person, or location.

5. Use interesting transitions between pages to dress up your presentation. But don't overdo everything with swooping, flashing objects and sound effects on every page.

6. Let the pictures stand alone, or add simple captions to each page.

If you plan to describe the photos during the presentation, you may want to eliminate the captions so the viewers will look at the pictures and listen to you rather than reading, as you can see in the following figure.

For business presentations, you probably won't need a caption. You may, however, want to include bullet points that cover the narration for that slide. Use fewer bullet points on that page and allow time for the viewer to look at your photos.

If you want, you can add sound narration to your slide show using your software's recording capabilities.

7. Consider putting together a *canned* (pre-packaged) presentation you can save on a disk and distribute for others to view on their own.

PowerPoint has a feature called Pack & Go that lets you package your presentations for viewing by others, even if they don't have PowerPoint installed on their computers.

Storing Digital Photos

Thanks to compression schemes like JPEG, digital photos don't take up nearly as much hard disk space as they might. Even so, you'll want to create archives of your pictures in order to move photos you don't view very often to convenient storage, and to provide a backup in case something bad happens to your computer. This section contains the high points.

For information storage, JPEG compression, and transferring images from your camera to your computer, ***see also*** Part III.

Archiving images on floppy disks

Floppy disks are cheap, readily available, and usable by anyone with a computer. Their drawback is that at 1.44MB, a floppy can't hold very many photos. If you have lots of floppies, a bunch of small photos, or don't mind copying them to many different disks, floppy disks might work for you. To store images on floppy disk:

1. If resolution isn't critical, save the images from your image editor using a healthy amount of JPG compression.

If you can squeeze photos down to 100K each, you can store 14 of them on a single floppy that might cost 25 cents.

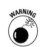

All the data you squeeze out of your photos via JPEG is lost — permanently.

2. If you want to be able to read the disks on both Macintosh and Windows computers, save them to a PC-formatted floppy, even if a Mac is your main machine.

Virtually all Macs made in the last decade can read PC floppies with no trouble, whereas few Windows machines can decipher a native Macintosh diskette.

3. Copy the photos to the floppy disk.

4. After you've stored your photos on a floppy, set the write-protect tab so you won't accidentally write over your archived files.

5. Store the disks in a dry, cool, safe place, and not in close proximity to magnets or devices that give off a magnetic field (such as your computer monitor).

Archiving images on high-density disks

Iomega Zip disks, Imation SuperDisks, and other high-density disks are more practical for archiving photos, because they hold 100 to 250MB or more of information.

For more information on with these media, *see also* Part III.

1. Save your images in the highest resolution you can. Because the images are archived, you want the best version available when you retrieve the picture to use later.

2. Create folders or subdirectories on the disk to help you classify the pictures. Or, if you've already created such folders on your hard drive, just drag and drop them to your archival media.

3. Save the images on the disk.

4. If your media has a write-protect tab, set it so that you can't accidentally write to the disks.

5. Store the disks in a dry, cool, safe place.

Archiving images on CD

If you or a friend or colleague has a CD writer, you can make permanent copies of your images for inexpensive, long-term storage. You can store them on two kinds of disc:

✔ **CD-R (CD readable):** Write-once media that cannot be erased.

✔ **CD-RW (CD read and writable):** You can update this information if you decide to change a photo and want to preserve only the latest version.

Just follow these steps to store images on CD:

1. Select the photos to be archived from among your collection.

2. Load your CD writing software.

3. Insert a blank CD-R or CD-RW disk in your CD writer.

The advantage of CD-R media is that they are very inexpensive — usually quite a bit under $1.00 a piece — and the information on the disks can't be changed. So you know that the image on the disc is the one you saved and hasn't been meddled with by someone else. The disadvantage is the information on the disks can't be changed. If you correct a mistake or otherwise change a photo, you must copy the new version to a different location on the same CD-R or onto a new CD-R. CD-RW media cost slightly more, but you can replace files with updated versions or erase the whole disc and start over.

4. Set the software to test the session (check everything out to make sure there are no problems with, say, locating one of the files you've specified) you plan to record before actually starting to record.

Because these images are going into an archive, you want to double-check them for errors before you inadvertently save a bad copy to your media. The normal "fixup" that all CD writer software does will catch most errors, such as files with names that are too long for the CD format you've selected, but doing a full test will let you determine whether or not all the images can be written to the disk without problems.

5. Start the disc recording. The following figure shows what you may see on the screen.

6. Store the finished disk in a dark, safe place. CDs aren't as prone to damage from slight amounts of moisture, but putting them away securely is still a good idea, especially if they are your only backup copy of your images.

7. Consider making a second copy of important images: one to take to work with on a day to day basis, and one to use as an archive.

Web Graphics

Digital images are perfect for Web graphics, because even the least expensive cameras produce far more resolution than is needed for a Web page. This section showcases some things you can do on the Internet.

Sizing a photo for a Web page

Good-looking images on a Web page are an attraction; long downloads are a distraction. The key to using images to encourage visitors to continue viewing your pages is to have graphics that appear quickly. You should maintain tight reins over the size and number of graphics on your Web page. Individual images should be 50K or less in size, and all the images on your page should amount to 100K or less. Follow these steps:

1. Select your very best images. Make sure they are appropriate for the page you want to post them on, and not just your favorites artistically.

2. Find the most important parts of the image and crop the extraneous material out using your image editor. A good size for logos or other images is about 128 x 128 pixels, but smaller is even better. More important images can be a little larger than that, but you rarely want an image as large as 320 x 240 pixels. *See Part* VII, "Editing Images," for cropping information.

3. If cropping won't get your picture down to reasonable pixel dimensions, use your image editor's resizing or resampling capabilities to reduce the image. In Photoshop, choose Image⇨Image Size, and then type a target pixel width (or height) in the Pixel Dimensions area of the Image Size dialog box.

4. View the file size of the modified image using your image editor's file information capabilities.

 Most image editors show the size of an image in kilobytes (or megabytes!) in a status line at the bottom of the screen. You may also find an Information choice in one of the menus. Photoshop's Image Size dialog box displays the final size before you apply the sizing modifications, as shown in the following figure.

5. Save the file using the directions in the "Compressing an image for the Web with JPEG/GIF" section later in this part.

Cropping a photo for the Web

Precisely crop any picture posted on a Web page to eliminate unnecessary image matter. All image editors have a crop tool, but you may find it difficult to line up all four edges exactly where you want them. Here's a method for precisely cropping an image to the exact pixel line you want. It works for cropping pictures for non-Web use, too:

For more information on cropping, *see also* Part V.

1. With the photo in your image editor, zoom out so you can see the entire image in your editing window.

 For this first step, being able to see all the image rather than having a large image for cropping is more important.

2. Using your editor's rectangular selection tool, draw a selection that's larger than the area you want to crop to.

3. Zoom in on the upper-left corner of the selection.

4. Use your image editor's selection "nudge" capability to move the selection pixel by pixel down and to the right until the top and left sides of the selection rectangle are exactly where you want them.

 Don't worry about the right and bottom edges of the selection rectangle; because your selection was larger than the area you want, those selection borders will encompass all you wanted to include in the cropped picture, plus more, as you can see in the following figure.

5. Activate the crop tool to clip off the extra image area above and to the left of the selection.

6. Create another selection; start in the bottom-right corner of the image and drag to include the rest of the area you want.

7. Zoom in on the lower-right corner of the image.

8. Use the nudge capability to move the right and bottom selection borders to the exact position you want.

9. Activate the crop tool.

 The image editor crops the image to the exact dimensions you specified.

For more information on editing images, *see also* Part VII.

Compressing an image for the Web with JPEG

One good way to reduce the file size of an image for a Web page is to squeeze it down using the JPEG compression option available in every image editor. JPEG discards some information so the picture will not be quite as sharp as it was originally, but on Web pages you will often scarcely know the difference. JPEG works best for full-color, photographic images, as opposed to text, line art or charts and graphs.

You'll find more information on JPEG and GIF formats in Part III.

Photographs work the best, because viewers may not notice the lost information in the jungle of detail in your image. Images containing text or a large number of diagonal straight lines work the least well, because the text or lines may appear blurry. Just follow these steps:

1. Select the image you want to squeeze with JPEG.

2. Make sure the image is a 24-bit full-color image.

 Digital camera images start out as 24-bit, full-color images, but you may have reduced the number of colors in your image editor. JPEG compression uses full-color images.

3. Save an extra copy of the image.

 After you discard image information using JPEG compression, you can't get it back, so keep an extra copy in case you want to work with the image further, or try compressing at a different quality ratio (the settings provided by the dialog box when you save in JPEG format).

4. Choose JPEG format from your image editor's Save or Save As menu item.

5. From the dialog box that pops up, choose a compression level.

Different image editors express the amount of compression in various ways. Some offer a numeric scale, from, for example, 1 (maximum compression/lowest image quality) to 12 (minimum compression/highest image quality), as shown in the figure that follows. Others may have a slider that you can move from Poor to Excellent. For Web graphics, most images look just fine at a setting in the middle. You can experiment with lower settings if you need to reduce the image even further.

6. Click OK in the dialog box to save the file as a JPEG image.

Compressing an image for the Web with GIF

GIF format is usually not the best for digital photographs, because GIF can use only 256 different colors, and full-color digital images can use any colors from a palette of 16.8 million hues. (No digital picture has anywhere near that many unique colors, of course.) However, if you have an image with few colors, GIF can produce even smaller file sizes than JPEG. GIF format is especially good for text and line art. Follow these steps:

1. Select the image to compress using GIF.

2. Access your image editor's GIF export facility. You may be able to simply Save As a GIF file, or need to use an Export.

3. In the dialog box that pops up, choose the number of colors or the GIF compression scheme you want to use.

The amount of compression a GIF export applies is determined solely by the number of colors you choose to represent. If your image has 256 or fewer colors, the dialog box may let you choose Exact mode, in which the GIF file contains all the colors in the original. Or, you may choose Adaptive mode, which selects a set of 256 colors that can best represent your image. You may also select a particular number of colors, such as 128, 64, or 32 hues, and the image editor will convert the colors of your image into one of the available shades as best it can.

4. Mark the Interlace box if you want your GIF file to appear on the screen faster during a download.

When a GIF is interlaced, a rough image appears on the visitor's screen first as the browser displays only the alternate lines of the graphic. The image becomes sharper as the rest of the image downloads.

5. If your image editor provides it, use Preview to see what the image will look like.

6. Click OK to save the image as a GIF graphic.

Once you've converted a full-color image to GIF, the extra colors that have been squeezed out are lost forever.

Creating a floating graphic

GIF files can also "float" above your background with part of the image rendered transparent. Here's the easiest way to create a floating photo logo or other graphic: Only GIFs and PNG files can be transparent, and most browsers don't support PNG.

1. Use your image editor's selection tools to select the portion of the image you want to float above the background.

2. Copy the image selection to the clipboard.

3. Paste the selection down in a new layer. The portion outside the selection will be transparent.

4. Use the image editor's GIF Export facility to save the image as a GIF.

5. In the dialog box that pops up, choose Transparency as the color to make transparent. Most image editors select Transparency for you automatically.

6. Choose the other parameters for a GIF file as described in the preceding section.

7. Click OK to save the image as a GIF graphic.

When placed on a Web page, the image will seem to float above the background, as you can see in the figure that follows.

Sending graphics in e-mail

Keep friends updated with family photos. Send product photos to colleagues or customers. If you have a digital camera, you can send your photos (no matter if GIF or JPEG) worldwide with a few clicks in your e-mail program. To be considerate of those who don't have super-fast Internet connections, crop your image down to no larger than 320 x 240 pixels. Here's how to send pictures via e-mail from start to finish:

1. Using your e-mail program, create a blank message.

2. Address the e-mail to your intended recipient(s).

 Many e-mail programs let you set up mailing lists so you can send a copy to everyone in your family, division, or organization at one time.

3. Enter the text that will accompany your photo.

4. Choose your e-mail program's command for attaching a file to the message.

 In Microsoft Outlook, choose Insert⇨File; in Outlook Express, choose Insert⇨File Attachment. With AOL e-mail, click the Attachments button at the bottom of the message dialog box. Then navigate to the location on your hard disk where the image is located.

5. Click OK or Send to mail your message.

Placing images on Web pages

To store an image on a Web page, you need nothing more than a Web page editor and the photos you want to include. AOL and many ISPs provide automated tools so that creating a Web page requires nothing but filling out a form, typing in text, and uploading pictures. The software takes care of building the final Web page and inserting the graphics for you. Just follow these steps:

1. Access the Web page building software.

2. If you're adding pictures to an existing Web page, log onto that page using the ISP's automated Web page building software.

3. If you're creating a new Web page, choose a template and follow the instructions to build the page.

4. Decide where you want the photos to appear, and upload them according to the instructions provided by your software.

5. Save your Web page and view it in your browser.

Sending graphics from Web pages

You can make your digital pictures visible anywhere on the Internet without the need to e-mail them, or even place them on a Web page (although that's a good idea, too). If you use AOL or an ISP that provides storage space, you can stockpile your images and make them available to anyone who knows the address, or URL of the picture. Just follow these steps:

1. Select the images you want to make available over the Web.

 You should apply the usual size constraints, but because the images won't appear on a Web page, you can use slightly larger photos.

2. Log on to your AOL or ISP-provided Web space.

 Your ISP usually includes software for accessing this space. With AOL, use Keyword FTP and visit your own personal Web space.

3. To keep things neat and tidy, create a subdirectory/folder especially for your pictures, with a name such as Images.

4. Upload the photos to this subdirectory/folder.

 You should probably use JPEG or GIF format. However, most browsers can still retrieve images saved in other formats such as TIF or PCX. Instead of displaying the image, the browser offers to save it to disk, where an image editor or another program can view it.

5. Supply the Web address of the photo to anyone you want to view it.

 This address, or URL, might be something like `http://members.aol.com/davebusch/vacation.jpg`.

6. Anyone can view the picture or download it to her hard disk by typing that URL into the browser.

 The following figure shows an example.

Appendix

Here's a quick reference to some additional resources you can draw on if you have additional questions or are interested in tasks not described in this book. All these were current when *Digital Photography For Dummies Quick Reference* was written, but keep in mind that Web site addresses change, books go out of print, and companies go out of business. Most of the material here should remain current for a long time, however.

In this part . . .

Image-Editing Add-Ons

Find some more image-editing tools and add-ons, such as filters and specialized image editing components, from these leading vendors. Filters work within your image editor to give you great special effects; other tools are stand-alone programs you can use to process your images.

For more information about image editing, ***see also*** Part VII.

Alien Skin

Alien Skin's Eye Candy and Xenofex are the absolute best add-on filter sets for Photoshop and compatible image editors. The company's a little warped, too, with its execs having very strange titles (for example, "coleporteurre").

Alien Skin Software

1100 Haynes Street, Suite Zero

Raleigh, NC 27604

919-832-4124

Andromeda

Andromeda provides a vast line of add-on filters that provide interesting photographic effects right within your image editor.

Andromeda Software

699 Hampshire Rd., Ste. 109

Thousand Oaks, CA 91361

805-379-4109

http://www.andromeda.com/

Extensis

Extensis markets a broad range of essential filters, including the Kai's Power Tools plug-ins from MetaCreations and PhotoTools. You can find some free downloads at their Web site.

Extensis Products Group

1800 SW First Avenue, Suite 500

Portland, OR 97201

503-274-2020

http://www.extensis.com

Nova Design

Find out about ImageFX and Alladin 4D.

Nova Design, Inc.

1910 Byrd Ave., Suite 204

Richmond, VA 23230

800-IMAGE-69/804-282-1157

Photography Instructions

To find out more about photography, books should be your first resource, because you can pull a book from your shelf and refer to it at any time, or even drop it in your camera bag for reference in the field.

General books

The leading publisher of general photography books is Amphoto. You can write to them for a catalog at Amphoto Books, 1515 Broadway, New York, NY 10036-8901, or call 212-536-5103.

For other titles, check out your bookstore or online book retailers like Amazon.com and Barnes & Noble for these great books:

- ✔ *Beyond Basic Photography: A Technical Manual,* by Henry Horenstein, Henry Asaacs, Henry Isaacs (Illustrator), Bullfinch Press

- ✔ *Fun With Digital Imaging: The Official Hewlett-Packard Guide* by Lisa Price, Jonathan Price

- ✔ *How to Photograph Your Baby: Getting Closer With Your Camera and Your Heart,* by Nick Kelsh; Stewart Tabori & Chang

- ✔ *National Geographic Photography Field Guide: Secrets to Making Great Pictures* by Peter K. Burian, Robert Caputo; National Geographic Society

- ✔ *The Lighting Cookbook: Foolproof Recipes for Perfect Glamour, Portrait, Still Life, and Corporate Photographs:* by Jenni Bidner; Amphoto Books

Wiley Publishing, Inc.

You can find these books at www.dummies.com:

- ✔ *Adobe PhotoDeluxe For Dummies* by Julie Adair King

- ✔ *Digital Photography For Dummies* by Julie Adair King

✔ *Photography For Dummies* by Russell Hart, Dan Richards

✔ *Photoshop For Dummies* by Deke McClelland

Schools

Photographic schools are a great way to learn photography in-depth, and the virtually only way to build the expertise you need to go into photography as a profession (aside from working alongside a photographer as an apprentice). Your local community colleges and vocational schools probably have some photo courses you can take. If you're interested in more professional-level instruction, here are some leading photo schools you'll want to investigate:

✔ **Brooks Institute of Photography:** 801 Alston Road, Santa Barbara, CA 93108; 805-966-3888; www.brooks.edu

✔ **International Center of Photography:** 1130 Fifth Avenue, New York, NY 10128; 212-860-1777; www.icp.org/

✔ **New York Institute of Photography:** 211 East 43rd Street, New York, NY 10017; 212-867-8260; www.nyip.com/

✔ **New York School of Visual Arts:** 209 East 23 Street, New York, NY 10010-3994; 212-592-2000; www.schoolofvisualarts.edu/

✔ **Rochester Institute of Technology:** Rochester, NY 14623; 716-475-2411; www.rit.edu

✔ **San Francisco Academy of Art College:** 79 New Montgomery Street, San Francisco, CA 94105; 800-544-ARTS/415-274-2200; www.academyart.edu

✔ **Santa Fe Workshops:** P.O. Box 9916, Santa Fe, NM 87504; 505-983-1400; www.sfworkshop.com

Web Sites

Web sites are your best source of up-to-date information on products and techniques. These sites are a gold mine of useful tricks, tips, and info.

Digital cameras

Digital camera technology seems to change weekly as new models with lower prices and more features hit the market. Here are some links to the Web sites of major digital imaging companies. These firms make cameras, scanners, software, and other products you'll find of interest. An updated list of these links can be found at www.dbusch.com/scanners.htm.

Overviews/reviews

Although the Digital Photography Review has lots of advertisements, it's a great source of information and reviews about a whole range of digital cameras. You can find all the news about recent product introductions here, too: www.dpreview.net/reviews/

Vendors

Here's the list of the Web sites of key vendors of digital photography equipment, storage devices, and related equipment. You'll find lots of information about cameras and other gear, photographic tips, trouble-shooting advice, and much more at many of these:

- **Agfa:** www.agfa.com
- **Artec:** www.artecusa.com
- **Avision:** www.avision.com
- **Caere Corp:** www.caere.com
- **Canon Computer Systems:** www.ccsi.canon.com
- **Casio:** www.casio.com
- **Compeye:** www.compeye.com
- **Epson:** www.epson.com
- **Ezonics:** www.ezonics.com
- **Fujifilm:** www.fujifilm.com
- **Fujitsu:** www.fujitsu.com
- **Hewlett-Packard:** www.hp.com
- **Kensington Technology:** www.kensington.com
- **Kodak:** www.kodak.com
- **Konica:** www.konica.com
- **KYE:** www.genius-kye.com
- **Largan:** www.largan.com
- **Logitech:** www.logitech
- **Memorex:** www.memorex.com
- **Microtek:** www.microtekusa.com
- **Minolta:** www.minolta.com
- **Mustek:** www.mustek.com
- **NEC:** www.nec-global.com

- **Nikon:** www.nikonusa.com

- **NuCam:** www.nucam.com.tw

- **Olympus:** www.olympus.com

- **Panasonic:** www.panasonic.com

- **Pentax:** www.pentax.com

- **PhaseOne:** www.phaseone.com

- **Philips:** www.philips.com

- **Plustek:** www.plustekusa.com

- **Primax:** www.primax.nl

- **Reality Fusion:** www.realityfusion.com/

- **Ricoh:** www.ricoh-usa.com

- **Samsung:** www.simplyamazing.com

- **ScanSoft:** www.scansoft.com

- **Scitex:** www.scitex.com

- **Sharp Electronics:** www.sharp-usa.com

- **Sony:** www.sony.com

- **Sound Vison:** www.soundvisioninc.com

- **Toshiba:** www.toshiba.com

- **Umax:** www.umax.com/usa

- **Visioneer:** www.visioneer.com

- **Vista Imaging:** www.vistaimaging.com

- **Xerox:** www.xerox.com

Image-editing software

If you need more information about image-editing software, here are some places to look. You'll find information about the products themselves, ideas for using them, patches to update software, and much more.

- **Digital photo albums**

 - **Flip Album:** www.softflip.com

 - **PhotoImpact Album:** www.ulead.com

✔ **Image editors**

- **Adobe Photoshop; Adobe PhotoDeluxe:** www.adobe.com

- **Corel Photo-Paint and Corel Painter:** www.corel.com

- **MGI PhotoSuite:** www.mgi.soft.com

- **Ulead PhotoImpact:** www.ulead.com

Photography

You can find a wealth of information available online about photography. You can find information about photographers, graphic design, using digital cameras, tips for selling your photos, and lots of other stuff.

✔ http://mavicausers.org/NYIphotoCover.html: Take a basic photo course in digital photography.

✔ http://members.home.net/jonespm/PJDigPhot.htm: Find other digital photography links in this large, well-researched list.

✔ http://www.askme.com: Ask the experts, for free, about any digital photography topic.

✔ http://www.kodak.com: Kodak has online photography courses that cover everything from composition to lighting.

✔ http://www.photo-seminars.com: Choose from a selection of online classes.

Glossary: Tech Talk

additive colors: The red, green, and blue (RGB) colors used to capture colors in a digital camera and to display images on a monitor.

ambient lighting: The natural existing lighting in a location.

anti-aliasing: A process that minimizes jaggy diagonal lines by using in-between tones to smooth the appearance of the line.

aperture priority: In aperture priority mode, you can set the aperture and the camera will adjust the shutter speed to provide the correct exposure.

archive: To store files that are no longer active, usually on a removable disk or tape.

aspect ratio: The proportions of an image; for example, an 8 x 10-inch photo has a 4:5 aspect ratio.

backlighting: Lighting effect produced when the main light is located behind the subject.

bitmap: A description of an image that represents each pixel as a number in a row and column format.

blur: To reduce the contrast between pixels that form edges in an image, softening it.

bracketing: Shooting several different pictures of the same subject at different f/stop and shutter speed combinations as a way of getting the best possible exposure.

brightness: The amount of light and dark shades in an image.

burn: To darken part of an image, using the Photoshop toning tool's Burn mode.

cache: An area of memory used to store information so that it can be accessed more quickly than data placed in slower RAM, on a hard disk, or other storage.

calibration: Adjusting a device such as a scanner, monitor, or printer so its output represents a known standard.

cast: A tinge of color in an image, usually an undesired color.

Clipboard: An area of memory used to store images and text so that they can be interchanged between layers, windows, or applications.

clone: To copy pixels from one part of an image to another with a rubber stamp tool.

close-up attachment: A device added to a lens to allow it to focus closer.

color correction: To change the balance of colors in an image, most often to improve the accuracy of the rendition, or to compensate for deficiencies in the color separation and printing process.

Compact Flash: A type of removable memory storage device.

compression: Reducing the size of a file by encoding using smaller sets of numbers that don't include redundant information. Some kinds of compression, such as JPEG, can degrade images, while others, including GIF and PNG, preserve all the detail in the original.

constrain: To limit a tool in some way, such as forcing a brush to paint in a straight line, or rotating an object in a fixed increment.

contrast: The range of individual tones between the lightest and darkest shades in an image.

convolve: A process used by imaging filters that takes the values of surrounding pixels to calculate new values for sharpening, blurring, or creating another effect.

crop: To trim an image or page by adjusting the boundaries.

darken: The process of selectively changing pixel values to a darker one.

depth of field: The zone of sharpness, which varies depending on how far you are from your subject and the size of the lens opening. At any given zoom setting, the larger the lens opening the smaller the zone of sharpness will be. You can adjust both focus and lens opening manually to change a picture's depth of field.

diffusion: The random distribution of tones in an area of an image, often used to represent a larger number of tones.

dithering: A method of simulating tones that can't be represented at the current color depth by grouping the dots into clusters of varying size. The mind merges these clusters and the surrounding white background into different tones.

dodge: A photographic term for blocking part of an image as it is exposed, lightening its tones.

dots per inch (dpi): The resolution of an image, expressed in the number of pixels or printer dots in an inch.

export: To transfer text or images from a document to another format, using the Photoshop Save As or Export functions.

file format: A way in which a particular application stores information on a disk.

filter: An image editor feature that changes the pixels in an image to produce blurring, sharpening, and other special effects.

focus: The distance from your camera at which your subject appears sharpest. Anything located significantly in front of or behind the focus point will appear to be less sharp.

font: Originally, a group of letters, numbers, and symbols in one size and typeface, but now often used to mean any typeface.

f-stop: The size of the lens opening; larger numbers admit less light; smaller numbers admit more light.

gamma: A numerical way of representing the contrast of an image's midtones.

gamut: A range of color values that can be reproduced by a particular color model or device.

Gaussian blur: A method of diffusing an image using a bell-shaped curve instead of blurring all pixels in the selected area uniformly.

halftoning: A way of simulating the gray tones of an image by varying the size of the dots used to show the image.

highlight: The brightest values in a continuous tone image.

hood: *See* lens hood.

hot shoe: A connector for attaching external flash units.

hue: A pure color.

Imation LS-120: A type of removable memory storage device.

infrared sensor: An infrared-sensitive device used to calculate distance from the camera to your subject for focusing or, in some cases, adjusting flash settings.

Some cameras also have an infrared emitter that you can use to transmit pictures to your computer or printer.

interpolation: A technique used to calculate the value of the new pixels required whenever you resize or change the resolution of an image, based on the values of surrounding pixels.

invert: The process of changing an image to its negative, exchanging black for white, white for black, and each color for its complementary hue.

Iomega Clik: A type of removable memory storage device.

ISO (International Standards Organization): A rating system used to compare the speed of films and digital camera sensors.

jaggies: The staircasing effect applied to edges of bitmapped objects that are not perfectly horizontal or vertical.

JPEG compression: A method for reducing the size of an image by dividing it into blocks of varying size (depending on the amount of compression requested) and representing all the pixels in that block by a smaller number of values.

lasso: A tool used to select irregularly shaped areas in a bitmapped image.

LCD: Liquid crystal display. Used to view the actual image seen through your lens.

LCD status readout panel: Used to view the number of exposures taken or remaining; quality level; flash status (on/off/automatic, and so on); and other information.

lens hood: A protective rim around a lens that shields the lens from light coming from outside the picture area.

lighten: An image editing function that is the equivalent to the photographic darkroom technique of dodging. Gray tones in a specific area of an image are gradually changed to lighter values.

line art: Usually, images that consist only of white pixels and one color.

magic wand: An image-editor tool used to select contiguous pixels that have the same brightness value, or that of a range you select.

marquee: The selection tool used to mark rectangular and elliptical areas.

midtones: Parts of an image with tones of an intermediate value.

moiré: An objectionable pattern caused by the interference of halftone screens, frequently generated by rescanning an image that has already been halftoned.

noise: Random pixels added to an image to increase apparent graininess.

opacity: The opposite of transparency; the degree to which a layer obscures the view of the layer beneath. High opacity means low transparency. Both terms are used in Photoshop.

optical viewfinder: The window you look through to frame your image.

optical zoom lens: Adjusts magnification of the image, making it larger or smaller.

palette: Tones available to produce an image, or a row of icons representing the available tools.

parallax: The degree that a non-through-the-lens optical viewfinder to show a slightly different image than the one seen through the taking lens.

Photo CD: A special type of CD-ROM that can store high-quality photographic images in a special space-saving format that provides several resolution levels of each image for different applications. That is, a high-resolution image can be extracted for printing and reproduction and a lower resolution image for display on a computer screen or Web page.

pixel: A picture element of a screen image.

plug-in: An image editor filter.

polarizing filter: A filter that cuts down glare that reflects off shiny surfaces such as glass and chrome. Outdoors it can provide dramatic clouds by increasing the contrast between clouds and a blue sky.

posterization: An image-editor effect produced by reducing the number of tones in an image to a level at which the tones are shown as poster-like bands.

power switch: A button used to make the camera active, turning on the sensor, making the electronic flash ready, and, often, illuminating the LCD (liquid crystal display) viewfinder.

resampling: The process of changing the size or resolution of an image by replacing pixels with additional pixels or fewer pixels calculated by examining the value of their neighbors.

resolution: The number of pixels, samples, or dots per inch in an image.

retouch: To edit an image, most often to remove flaws or to create a new effect.

RGB: *See* additive colors.

rubber stamp: An image-editor tool that copies or clones part of an image to another area or image.

saturation: The purity of color; the amount by which a pure color is diluted with white or gray.

scale: To change the size of a piece of an image.

selection: An area of an image chosen for manipulation, usually surrounded by a moving series of dots called a selection border.

shadows: The darkest part of an image holding detail.

sharpening: Increasing the apparent sharpness of an image by boosting the contrast between adjacent pixels that form an edge.

shutter priority: In shutter priority mode, you can set the shutter and the camera will adjust the aperture to provide the correct exposure.

SLR: Single lens reflex. An optical viewfinder system that shows the image through the taking lens.

SmartMedia: A type of removable memory storage device.

Sony Memory Stick: A type of removable memory storage device.

telephoto lens: A lens that makes objects appear larger.

threshold: A predefined level used to determine whether a pixel will be represented as black or white.

time exposure: A very long exposure of several seconds or more, usually used in low light.

tripod socket: A screw-threaded socket that you can use to attach tripods, special handgrips, electronic flash attachments, and other equipment to a digital camera.

unsharp masking: The process for increasing the contrast between adjacent pixels in an image, increasing sharpness.

USB: Universal Serial Bus. An interface used to connect digital cameras to a computer.

wide-angle lens: A lens that makes objects appear farther away.

zoom: To enlarge part of an image so that it fills the viewfinder, making it easier to work with that portion.

zoom lens: A lens that can produce an image of varying sizes through a continuous range of magnification. Zoom lenses for digital cameras are usually described in terms of the magnification ration, such as 1:3 or 1:4.

Index

Notes

Notes

Notes